General Editor
David Piper

Holbein

Every Painting

Holbein, Hans, the Younger

Introduction by Roy Strong

Director of the Victoria and Albert Museum, London

RIZZOLI
NEW YORK

Foreword by the General Editor

Several factors have made possible the phenomenal surge of interest in art in the twentieth century: notably the growth of museums, the increase of leisure, the speed and relative ease of modern travel, and not least the extraordinary expansion and refinement of techniques of reproduction of works of art, from the ubiquitous colour postcards, cheap popular books of colour plates, to film and television. A basic need – for the general art public, as for specialized students, academic libraries, the art trade – is for accessible, reliable, comprehensive accounts of the works of the individual great masters of painting; this has not been met since the demise before 1939 of the famous German series, *Klassiker der Kunst*; when such accounts do appear, in the shape of full *catalogues raisonnés*, they are vast in price as in size, and beyond the reach of most individual pockets and the capacity of most private bookshelves.

The aim of the present series is to provide an up-to-date equivalent of the *Klassiker* for the now enormously enlarged public interested in art. Each volume (or volumes, where the quantity of work to be reproduced cannot be contained in a single one) catalogues and illustrates chronologically the complete paintings of the artist concerned. The catalogues reflect as far as possible a consensus of current expert opinion about the status of each picture; in the nature of things, consensus has yet to be reached on many points, and no one professionally involved in the study of art-history would ever be so rash as to claim definitiveness. Within the bounds of human fallibility, however, every effort has been made to achieve both comprehensiveness and factual accuracy, while the quality of reproduction aimed at is the highest possible in this price range, and includes, of course, colour. Every effort has also been made to hold the price down to the lowest possible level, so that these volumes may stay within the reach not only of libraries, but of the individual student and lover of great painting, so that they may gradually accumulate their own 'Museum without Walls'. The introductions, written by acknowledged authorities, summarize the life and works of the artists, while the illustrations place in perspective the complete story of the development of each painter's genius through his career.

David Piper

Introduction

Hans Holbein the Younger remains one of the enigmas of the history of art. The combination of the keenest and most accurate analytical eye in Renaissance painting with our total ignorance of his true personality gives him an extraordinary fascination. There exists no autobiography, no notebooks or letters. His life can ônly be told in terms of dates, official documents and his works. Of Holbein the man there is little beyond the self-portraits with their somewhat unattractive, disagreeable gaze. For someone who moved in the intensely literary world of Humanism at its apogee, who counted among his friends and admirers Erasmus, Froben, Sir Thomas More, and the poets and men of letters of Henry VIII's court, this is all the stranger. He remains an enigma.

I

Hans Holbein was born in the town of Augsburg in 1497–8 into the family of a painter of the same name. He and his elder brother, Ambrosius, were destined from an early age to follow in their father's footsteps and in 1514 were sent to the town of Basel and apprenticed to the artist Hans Herbster. Holbein's earliest works date from the following year and are still in the Late Gothic style of his father's workshop, something which training and travel were shortly to alter radically. Some time during this period Holbein went to Italy, but exactly where can only be inferred from his work. In the main his experiences seem to have been confined to the north, to the Lombard plain, Milan, possibly Venice and Mantua, but probably not Rome or Florence. Leonardo and his followers, plus the work of Andrea Mantegna, seem to have made the largest impact. Recollections of these masters recur throughout Holbein's work, even in England twenty years later.

On his return to Basel he quickly established himself as a painter of outstanding talent. This was an enormously productive period, the studio pouring out altarpieces, portraits, designs for stained glass, besides undertaking a series of monumental commissions: the *Hertenstein House* in Lucerne (No. 18), and in Basel the *House of the Dance* (No. 23) and the paintings in the Council Chamber of the Town Hall (Nos. 27–38). Many of these works have long since vanished through decay, many others must have been destroyed in the holocaust of destruction that attended the advent of the Reformation in the city. All this makes the reconstruction of Holbein's early period extremely problematic. We also have no knowledge as to the size, number or structure of the studio. More important, however, was his relationship with the great publishing house of Froben (see Nos. 40, 44) and throughout these years he produced a large number of designs for woodcuts, including the *Dance of Death* and illustrations to the Old Testament.

In 1524 he broadened his education by a visit to France, to Lyons and Avignon. The influence of this journey can be traced in his designs for the decorative arts and in his portraiture which shows a familiarity with the work of the Clouet school. But by 1526 his career abruptly changed course under the impact of the Reformation, which took an extremely violent form in the cities of the Swiss confederation and removed the major source of any artist's income: the production of works of art for churches. At this stage Holbein must have begun looking elsewhere for employment, at least until the storm had blown over.

Holbein's work was already known in England from the two portraits he had painted in 1523 of Erasmus (Nos. 41, 42), one of which had been a present to William Warham, Archbishop of Canterbury. This is the portrait, now at Longford Castle (No. 41), which depicts the great scholar posed like a St Jerome in his study. Numerous copies exist, but whether by the hand of Holbein or of his studio has yet to be proved.

These two portraits of Erasmus preface Holbein's first visit to England. The artist left Basel towards the end of August 1526 equipped with introductions by Erasmus to the circle of Sir Thomas More. The latter provided the artist with all his initial commissions: the lost *Family Group* (No. 53), which

must have been a startling innovation for the still Gothic eyes of Early Tudor England, in addition to single portraits including the famous one of More himself now in the Frick Collection (No. 56). The *Family Group* was finished before 7 February 1527 when a drawing of it (No. 53b) was sent to Erasmus with annotations identifying the sitters in the hand of the mathematician and astronomer Nikolaus Kratzer.

No artist with Holbein's skill or with his experience of all that had been achieved in Renaissance Italy had been seen in England. But there is no sign that his arrival created any interest at court. Henry VIII had yet to embark on his major period of art patronage and the appreciation of Holbein focused on a small, interconnected group of English humanists. Nothing like the *More Family Group* was in fact to be seen in England for another hundred years. Drawing on his knowledge of Mantegna's depiction of the Gonzaga court in the *Camera degli Sposi* at Mantua, but echoing the iconographic formula for a Holy Family or a Disputà, the household of Sir Thomas More is placed within an actual room of the Chelsea house. Its verisimilitude is amazing.

His other sitters were almost all correspondents of Erasmus: *Sir Henry Guildford*, Comptroller of the Royal Household, and his wife (Nos. 59, 60), *William Warham*, Archbishop of Canterbury (Nos. 58–58c), *Nikolaus Kratzer*, tutor in mathematics and astronomy to the More family (No. 62) and the enchanting *Lady with a Squirrel* (No. 54), who must again be an unidentified member of the circle. Two of these sitters had connection with another work which brought Holbein directly into the orbit of the court. In May 1527 an elaborate temporary *salle des fêtes* was erected for the reception of ambassadors from Francis I, King of France. Part of its decoration was an immense triumphal arch *à l'antique* (not by Holbein) backed by a panoramic painting of the siege of Thérouanne 'very cunningly wrought', we are told, by 'Master Hans'. Through this arch the revellers were to pass to a mighty banquet in a room beyond, the ceiling of which was covered with the planetary and zodiacal signs. This was devised by Kratzer and designed and executed under Holbein's supervision.

In this way, by the spring of 1527, Holbein was well on the way towards entering royal service. The next fact we know is that on 29 August 1528 he had purchased a house in Basel. His return is not surprising since the Town Council had only granted him a two-year leave of absence. Holbein would, therefore, have feared his loss of rights as a citizen of the city if he had delayed in England any longer. The four years that followed were years of the utmost turbulence as the Reformation took its course. Mob iconoclasm broke out with a consequent clearing out of sacred art from the churches, an emptying that must have taken along with it much of Holbein's early work. Whatever was movable was carried out, broken and burnt. Whatever was left on the walls was defaced and painted over. The era of peaceful church reform had passed and Erasmus, who epitomized peaceful reform, left Basel for Freiburg. In the spring of 1529 the Reformist party issued an order forbidding images in churches, thus finally removing from Holbein the hopes of any further religious commissions. In addition, the painter's own religious views were on the side of reform, even though his exact position is not known. Certainly with the cessation of the religious commissions, the chance of employment greatly diminished. The type of work he could expect was embodied in the decision by the Town Council to finish the internal decoration of the Council Chamber which Holbein had begun some years before. The subject matter was now Old Testament and distinctly admonitory and reformist: *Rehoboam rebuking the Elders of Israel* (No. 29) and *The Meeting of Samuel and Saul* (No. 37). Such was the continuity of religious turmoil and lack of patronage that, some time between the end of 1531 and the spring of 1532, Holbein left for England.

II

Holbein's second English period falls into three distinct phases. It opens with initial employment by the merchants of the German Steelyard, it continues with his assimilation into the circle of Thomas Cromwell, and culminates in his work for Henry VIII and his court until his death in 1543. When Holbein returned to England the gentle reforming humanist milieu of the More circle was about

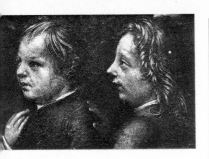

Above: *The two brothers as they appear in a detail of their father's painting* St Paul's Cathedral *(Augsburg, Staatliche Gemäldegalerie)*

to be swept away by the tide of events which made up the English Reformation. Archbishop Warham died in 1532, thus opening the way for the appointment of Thomas Cranmer as his successor and the King obtaining his divorce. Sir Thomas More fell from power in 1534 for refusing to take the new Oath of Supremacy whereby Henry VIII's assumption of the role of Supreme Head of the Church of England became fact. Simultaneously with the break with Rome came a programme of regal apotheosis that began to express itself directly in terms of a massive patronage of the visual arts centring on building on a colossal scale. Between 1530 and 1533 Cardinal Wolsey's York Place, which he had surrendered to the crown, was transformed at speed into Whitehall Palace in order to receive Anne Boleyn as queen. The Cardinal's second waterside house at Hampton Court, similarly made over, underwent a huge expansion in size through the 1530s, while in 1538 Henry embarked on his greatest folly of all in emulation of Francis I, the palace of Nonsuch.

In spite of the fact that a small army of painters was working in Whitehall between 1530 and 1533, Holbein was not to be numbered among them. His work was for the London agency of the Hanseatic League, in portraits such as *Hans of Antwerp* (No. 68) or *Derich Born* (Nos. 79, 84), but principally in the two lost monumental paintings depicting the *Triumphs of Riches* and *Poverty* (Nos. 70, 71) for their Banqueting Hall. These were rich in allusions to every aspect of the Renaissance

iconography of triumph, whether antique or Petrarchan, and above all owe a profound debt to Mantegna's *Triumphs of Caesar*. For the Merchants, too, he designed a pageant arch for Anne Boleyn's entry into London in May 1533, an arch upon which Apollo and the Muses sat on the mount of Parnassus with the fountain of Helicon before them.

There is no doubt, however, that Holbein entered royal service by means of the politician who master-minded the machinery and propaganda of the Reformation, Thomas Cromwell (No. 96). The latter was acutely aware of the value of visual propaganda for the new regime. As one of his apologists wrote: 'Into the common people things sooner enter by the eyes than by the ears, remembering more better that they see than that they hear.' Holbein's value would be appreciated as a designer of woodcuts for the publishers and, under Cromwell's aegis, he was responsible for the title page to Coverdale's translation of the Bible into English, which was deliberately Protestant and royalist in its subject matter, and a series of anti-clerical woodcuts in which the scribes and pharisees are garbed as monks and clergy.

Holbein took up his place as King's Painter in 1537. To the years following belong the most famous portrait image, that of Henry VIII as conceived for the King's Privy Chamber, his principal private as against public state room, in Whitehall Palace. This wall-painting was destroyed by fire in 1698 and we now know it only from copies made in 1667 (No. 110b) and 1669 and from the original drawing for the figures of the King and his father Henry VII (No. 110a). From the fragmentary sources at our disposal this seems to have surrounded a window, and its perspective is that of an altarpiece to which people gazed up. Nothing quite like it had been seen in England before. Again it was rich in allusions to the art of the Italian Renaissance but its prime impact, as with all Holbein's work, must have been its astounding verisimilitude in rendering the two kings and their queens. In the figure of Henry VIII Holbein created arguably the most famous royal portrait of all time, encapsulating in this gargantuan image all the pretensions of a man who cast himself as 'the only Supreme Head in earth of the Church of England'. Not only

5

had Holbein drawn on the reality of the man but he had also placed him, legs astride, in a pose derived from the Florentine *quattrocento* for heroic exemplars such as Donatello's *St George* or Pollaiuolo's *David*. But the masterstroke came during the execution of the painting. Henry's face, which in the cartoon is inclined towards his queen, Jane Seymour, was deliberately turned towards the spectator.

So powerful was this image as an epitome of the post-Reformation idea of monarchy that it was adapted for Edward VI and revised early in the next century for Henry VIII's namesake, Henry, Prince of Wales, eldest son of James I. However, there will always remain the problem as to which, if any, of the innumerable versions of varying size which survive of this portrait, forms part of the production of Holbein's studio. Ironically, only one portrait of the King is unanimously accepted as entirely by Holbein's hand, the little half-length in the Thyssen collection (No. 106), once part of a diptych with a portrait of his third queen, Jane Seymour.

Holbein's final image of Henry is that in the *Barber Surgeons* group (No. 130), in which he sits formalized like God the Father, a figure of *divina majestas*, in a frontal position, flanked by the Company members in the pose of suppliants before the Madonna or saints. Verses suspended on a cartouche proclaim 'the light of the Gospel' which, thanks to this monarch, now 'flies around on glowing wings'.

So much for Holbein and the King. But what of his wider role at court? It is all too easy to forget that Holbein was, for instance, paid half the salary of that of the royal miniaturist, Lucas Hornebolte, who taught him the art of limning. It is also easy to overlook the fact that Holbein was only one of a great number of artists and craftsmen, both native and foreign, who were engaged in the decoration of the royal palaces. There was Nicholas de Modena, trained in the tradition of Primaticcio and Rosso, who worked at Nonsuch, the exterior of which was covered with *bas-reliefs* in the manner of the celebrated galleries at Fontainebleau. There was the artist-engineer Girolamo da Treviso, author of the picture at Hampton Court of the Evangelists stoning the Pope; the painter

John Raff (probably identifiable with Johannes Corvus), who supervised an important series of murals in the Orchard Gallery at Whitehall on the subject of the King's coronation and the Field of Cloth of Gold Giovanni da Maiano in the 1530s was working on Henry VIII's tomb at Windsor Castle and probably also the choir screen of King's College, Cambridge, a monument to direct Italian influence and a crucial document indicating the stylistic nature of the interior decoration of Whitehall. There was another Florentine, Toto del Nunziata, who designed costumes and scenery for court fêtes and whose name has with reason been attached to the arabesque panels now at Loseley House which are derived from Raphael's revival of the *grottesche* for the Vatican *loggie*. In other words, although the break with Rome in 1533 and the Reformation were ultimately to stultify contact with the achievements of the High Renaissance in Italy, throughout the 1530s and until well into the reign of Edward VI that severance did not bite deeply. The severance did not occur until the generation of visitors died off leaving no successors. It is crucial to understand this in order to assess Holbein's contribution to portraiture and the decorative arts. The designs for jewellery and plate for the court with their abundant use of antique motifs would have been entirely consonant with the other work being produced by artists at the same time but which has not survived or has yet to be disentangled.

There was never anything in the least mechanical or formulistic in Holbein's approach to his portrait commissions. Those who sat were undergoing, almost without exception, a new experience, one which was a profound visual expression of humanist ideals. Those closest to the spirit of the ideals find it reflected in the formula chosen for their likeness. *Erasmus* is posed, as the evangelists of old were painted, in the act of writing (Nos. 42, 43). *Sir Thomas Wyatt the Younger* (No. 132) is presented with the clean-cut precision of an antique gem. *Surrey* the poet (No. 134) clutches his cloak like a toga in a pose echoing antique busts. *Simon George of Quotoule* (or *Quocote*) (No. 97) is again turned in medallic profile. The attributes that surround the sitters are expressions of their rank and office and all are observed with

startling fidelity: *Warham*'s mitre and crozier (Nos. 58, 58b–c), *Kratzer*'s mathematical and astronomical instruments (No. 62) or the complex series of objects, each with its particular significance, that rest on the table between *The Ambassadors* (No. 86). This treatment is essentially typical of the early portraits until Holbein enters royal service. From about 1535 onwards there is an abrupt change. Portraits rarely contain any attributes and the eye is tightly focused on the face and costume. One is less and less aware of three-dimensional space as inscriptions are floated across the blue backgrounds.

All the time, too, there is an ability to move up or down in scale. Holbein's miniatures reveal an astounding skill in adapting his own monumental style to a minute size. But the large-scale oil paintings can move from the half-scale of *Margaret Wyatt, Lady Lee* (No. 120) up to the over-life-size figure of Henry VIII in the wall-painting (No. 110). It is this very variety, always entirely effortless, which is so remarkable. However similar some of the poses might be, it is true to say that the eyes of the sitter never actually hit those of the onlooker in quite the same way. All the pictures, too, which are wholly autograph, have a quality of sheer craftsmanship which is essentially in the northern Gothic tradition. Already Titian was moving the art of portraiture along a new path, broad and impressionistic in its treatment. England was to have to wait for this until Van Dyck came a century later.

Holbein's mastery of the technique of miniature painting left a powerful tradition in England where the art was to flourish for three hundred years. Lucas Hornebolte, who taught him, had been brought over from the Low Countries where he was the leading exponent of the Ghent-Bruges School. Hornebolte's miniatures stretch over two decades from 1525, when he arrived in England, until his death in 1544. Their formula and technique stem directly from portraiture in late medieval manuscript illumination. To this Holbein was to add all his powers of monumental design aligned to psychological penetration of character and thus was far to excell his master in miniature. Less than a dozen miniatures (Nos. 146–155) can be associated with him with any degree of confidence. Essentially they represent his large-scale formula miraculously shrunk small.

Holbein died of the plague in the autumn of 1543. Did he or did he not leave a school? At the moment this remains one of the problems confounding the study of mid-sixteenth century English art. At court taste was changing away from the truth of Holbein's portrait tradition to one much more glossy and evasive, that concentrated on surfaces rather than penetrated them. By 1545 he was replaced as King's painter by William Scrots, formerly court painter to the Regent of the Netherlands, whose work epitomized this new approach. One artist and one only was to take the Holbein tradition in its essentials on into the reign of Elizabeth I and that was John Bettes the Elder (*fl. c.* 1531, d. before 1570). As his work is gradually being disentangled we can see that it alone embodies the reality of Holbein's vision of human nature and inherits his stylistic tricks such as the delineation of the thickness of an eyelid. And as far as we know, he never received court patronage. It was not until the troubled years of the middle of the century were over and the Elizabethan age was about to enter its apogee that the art of painting was again to flourish. The master of that age was the miniaturist Nicholas Hilliard who wrote, 'Holbein's manner of limning I have ever imitated, and hold it for the best'. In Hilliard's delicate and sensitive observation of the successors to Holbein's sitters who gathered around the throne of Gloriana we find the inheritance of Holbein's art taken on into the new century.

III

Although so little is known about Holbein's studio the actual technical processes of creation are relatively easy to follow from the surviving visual evidence. For Holbein everything began with a drawing. This was a common practice for artists of the northern Renaissance from Cranach or Dürer to the Clouets. In the case of Holbein we know that a sitting of three hours duration was sufficient to make a 'very perfect' likeness, for this was precisely the length of time granted to him in 1538 when he visited Brussels in the entourage of Sir Philip Hoby to paint *Christina, Duchess*

of Milan (No. 112) as a prospective bride for Henry VIII.

The technique he used for these drawings varied. During his first period in England they are usually in chalks, with an occasional use of watercolour but never ink. During his second period the tendency was to draw on pink prepared paper, still with chalk and watercolour but with an increasing emphasis on the emphatic line made with ink and brush. The suggestion that he made use of a mechanical contrivance to record the rudimentary outlines of a sitter's features is now generally accepted. Pressure of business alone precluded long sittings by aristocrats of the court.

The results of these encounters we see vividly in the famous Windsor drawings, the most astoundingly vivid record that survives of the personnel of a Renaissance court. For Holbein the drawing was not only one stage in the portrait process but, like those of the Clouets, it had value in its own right. Only the early drawing of Sir Thomas More has pinpricks for transfer to the panel, ones which match exactly with those visible in an X-radiograph of the picture. This was a technique he reserved for his monumental commissions such as the Privy Chamber wallpainting and the *Barber Surgeons* group, the cartoons for which were made up of cut-out sheets of paper containing separate studies all laid down on to a large sheet and pricked for transfer (No. 131). The other drawings were used as studio reference for the manufacture of a portrait, not even for tracing, because Holbein was quite capable of altering the scale of the face as he did, for example, in the case of *Sir Henry Guildford* (Nos. 59, 59a). Time and again the drawings contain notes on colour and details of dress and jewellery. There is no evidence, however, that a drawing always presupposes a portrait.

The pictures themselves are within the technical tradition of painting typical from the Van Eycks onwards. To the panel he would transfer the drawing in monochrome in pen and wash making use of geometrical instruments. The surface of the picture would then be carefully and painstakingly built up in oil and tempera with microscopic observation of costume and jewellery. No blemish is omitted. The wound on the neck of *Sir*

Richard Southwell (No. 102) is rendered with complete fidelity. The blind right eye of the *Earl of Bedford* is recorded in the drawing (No. 118a) even if a later hand has inserted a seeing one. Any study of the picture surface of an autograph Holbein is always a revelation of detail. Every stitch on a garment, every pin or fastening of one of the extraordinary headdresses is there. One also feels the tension and shape of the undergarments, the structure beneath the surface of a court dress. The head attire of the ladies could be reconstructed, so accurate is the delineation of their jewelled framework, and the fabrics that composed them. The *Jane Seymour* (No. 107) in the Kunsthistorisches Museum can be cited as a *tour de force* of costume and jewellery, a feature which makes Holbein our most valuable source for the history of early Tudor costume. By the time he was painting pictures of this kind, the lavish use of gold leaf and paint for embroidery and to highlight jewels was old-fashioned within a European context.

Another technical feature which is typical of Holbein is the raised background. This can most clearly be seen, for instance, in his *Christina, Duchess of Milan* (No. 112) where, if the viewer catches the panel with the light falling on to it at an angle, the figure will be seen to be inset with the blue background raised above it. In the case of a picture such as *Sir Thomas Wyatt the Younger* (No. 132) wisps of brown hair are painted curling up over on to the raised ground. This treatment of the panel surface was not followed by his successors in Tudor England. The only artist who worked in this way was the mysterious Master John who painted Mary I as Princess in 1544 and Lady Jane Grey at about the same time (both National Portrait Gallery, London).

Our lack of knowledge about Holbein's studio presents almost insurmountable problems in the study of his paintings during his second English period. To complicate the issue, the tradition of painting which he embodied was vigorous even if in diminished form until well into the seventeenth century, enabling copies of extremely high quality to be produced. An example of this is the portrait of *Archbishop Warham* at Lambeth Palace (No. 58b) which was long believed to be the original or, at least, a second version

from Holbein's own hand. Dendrochronology, the process of establishing the date of a picture by the growth rings of the tree making up the panel, has definitely established that the Lambeth version is a copy made when the original was sold to the Holbein collector, Andreas de Loo, in the Elizabethan period. We have drawings for which no paintings survive. We have instances of drawings plus paintings which are only copies of a lost original. Apart from the connoisseur's eye, which never totally agrees, dendrochronology must be the only way of elucidating which pictures were actually painted before 1543. When this has been accomplished we shall be able to know whether there was studio production or not and, if there was, how it worked, what was its quality and the size of its output.

IV

Throughout his life Holbein, like any other great master, was open to and excited by all that was being created in the visual arts in his own age. He was able to respond and assimilate into his own style, without imitation, the Late Gothic tradition of his father's workshop, the attainments of the Renaissance in northern Italy, in particular those of the Milanese school, and finally the art of early sixteenth-century France, in particular the portraiture that we associate with the Clouets and their followers.

Holbein's art began squarely within the ambience of the Late Gothic traditions of his father's studio in Augsburg. From this background he inherited the northern European Gothic insistence on line together with a preoccupation with reality as against idealization. His earliest religious works are peopled not by ideal types but by portrait figures and there is never any flinching from the most dispassionate delineation of the cruelties of the Passion. *The Flagellation of Christ* (No. 9) belongs to this tradition, of which Grünewald is perhaps the most noteworthy exponent, in which nothing of the physical horror and degradation is spared. On this foundation Holbein was to assimilate both directly and indirectly the achievements of Renaissance Italy. On a superficial level there was an assimilation of antique decorative detail which from his return to Basel onwards is introduced heavily into both his monumental works and his portraits. Jakob Meyer and his wife (Nos. 10, 11) typify this in the case of the latter; his diptych of the *Man of Sorrows* (No. 21A) and the *Mater Dolorosa* (No. 21B) shows its introduction into his religious works, while the most striking form it took was to be the vast exterior decoration schemes of the *Hertenstein House* at Lucerne, the *House of the Dance* at Basel (Nos. 18 and 23) and in the interior wall-paintings of the town's Council Chamber (Nos. 27–38). In all these there is not only an insistent use of antique motifs but also the use of classical architecture by which he was able to divide the wall into spaces. There is also an obsession with the new art of single point perspective reflected in the geometry of the columns,

Monograms and dates inscribed by Holbein in the paintings BENEDIKT VON HERTENSTEIN *(No. 16) and* CHRIST IN THE SEPULCHRE *(No. 26)*

arches and receding walls which betray in particular his knowledge of Mantegna. The most striking instance of his pleasure in perspective experiments is the two wings of the *Oberreid Altarpiece* (Nos. 25A–B), one set by day, the other by night, but both embraced within sharply receding complementary architectural perspectives.

The use of the rediscovered repertory of antique decoration is never as insistent in his later work. In content it belongs to the fifteenth rather than the sixteenth century. By his first English period it is exceptional. The column in *Lady Guildford* (No. 60) is its swan song. The one spectacular exception is the elaborate architectural background to the Privy Chamber group of 1537 of *The Family of Henry VII* (Nos 110a–b), which includes direct quotations after engravings after Mantegna. Otherwise it is confined to his designs for woodcuts and the decorative arts. Even a portrait as grand as that of *Christina, Duchess of Milan* (No. 112) makes no use of architecture. The rise and fall of Holbein's use of classical architecture in his portraits is an index to his increasing refinement of observation and his progressive elimination of any inessentials that might detract from the scientific study of the sitter. His interest in perspective was shared by Leonardo da Vinci whose work or, rather, school had a lasting influence on Holbein. They shared an approach to painting which we can only describe in modern terms as being scientific in its microscopic examination of externals.

The art of Leonardo seems to have reinforced Holbein's Gothic impulse with a Renaissance scientific overlay. The impact of Leonardo must have been very powerful for him to have indulged in what was virtually a pastiche of the *Last Supper* (No. 49). Technically, too, the Leonardesque helped him to form his style. This is reflected in his use of a dry medium with resin or linseed oil and the *sfumato* treatment of surfaces. The poses of his sitters thenceforward reflect knowledge of the Milanese and Venetian schools. *Lais* (No. 52) and *Venus and Cupid* (No. 51) are obviously heavily indebted to the Leonardesque with their use of the enigmatic smile of the sitter with the *sfumato* technique, plus the placing of the sitter behind a balustrade typical of portraits by Bellini, a motif which

was to recur until his second English period.

His visit to France taught him the method of drawing with coloured crayons but also exposed him to the simple portrait formulae of the Clouet School. There the accent was entirely on the sitter silhouetted against a plain ground. As Holbein's career developed he tended more and more to simplify, to reduce his portraits in size and to jettison elaborate settings crowded with symbolic attributes. This happened gradually, over the period of a decade.

Seen within a European context Holbein, by the year of his death, was old-fashioned. The heroic age of human reality embodied in the High Renaissance portrait had already given way to the Mannerist era. In Florence Bronzino was creating his icons of the Medici dynasty in which an obsession with surface trappings and stylishness of presentation were used to conceal the reality of a sitter. The face becomes the mask set into a cosmetic of appropriate accessories. With this development Holbein's work was destined to go into more than a degree of eclipse for over half a century. Not until after the advent of the Stuarts in 1603 did the appreciation of Holbein revive in England. And this revival was to centre on the virtuoso collectors Henry, Prince of Wales, his brother, the future Charles I, Thomas Howard, Earl of Arundel and two ladies of the Court, Lucy Harington, Countess of Bedford and Lady Fanshawe. The Merchants of the German Steelyard presented Prince Henry with the *Triumphs of Riches* and *Poverty*. His tutor, Adam Newton, gave him a portrait of Erasmus. Arundel possessed among others *The More Family Group*, the portraits of *Christina, Duchess of Milan*, the *Earl of Surrey*, the *Duke of Norfolk*, *Sir Henry* and *Lady Guildford*. Abraham van der Dort's catalogue of Charles I's collection lists almost thirty works including *Hans of Antwerp*, *William Reskimer* and a whole series of miniatures. However, by that time his name was being indiscriminately applied to works by other artists and to a myriad of copies, both facts resulting in consequences which are with us to this day and still defy the exact definition of the art of Hans Holbein the Younger.

Roy Strong

Catalogue of the
Paintings

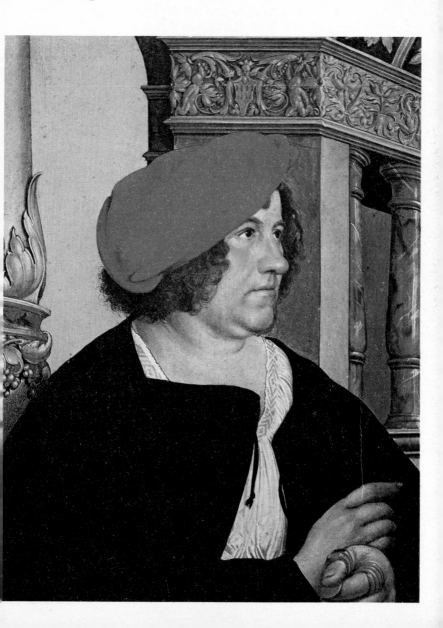

All measurements are in
centimetres
s.d. = signed and dated

1 Painted Table for Hans Baer
Oil on tempera on wood/
102 × 136/s.d. 1515
Zürich, Schweizerisches
Landesmuseum

2 The Procession to Calvary
Oil and tempera on wood/
74 × 140/s.d. 1515
Karlsruhe, Staatliche
Kunsthalle

3 Head of a Saint
Oil and tempera on wood/
23.5 × 21.5/c. 1515–16
Basel, Öffentliche
Kunstsammlung

4 Head of a Crowned Saint
Oil and tempera on wood/
23.5 × 22/c. 1515–16
Basel, Öffentliche
Kunstsammlung

PASSION CYCLE
(Attributed work)
5 The Last Supper
Oil and tempera on canvas/
144 × 155/c. 1515–16
Basel, Öffentliche
Kunstsammlung

Jakob Meyer (No. 10). (p. 11)
The pair of husband and wife
(Dorothea Kannengiesser,
No. 11) are united by their
architectural setting.
Belonging to the robust
bourgeois tradition of German
painting, they make an
interesting comparison to
Holbein's courtly formalism
twenty years later in his
portraits of Henry VIII and
Jane Seymour.

Dorothea Kannengiesser
(No. 11).
Wife of Jakob Meyer.

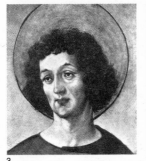

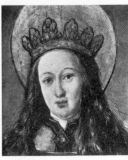

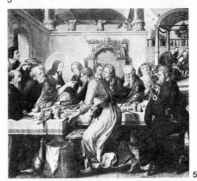

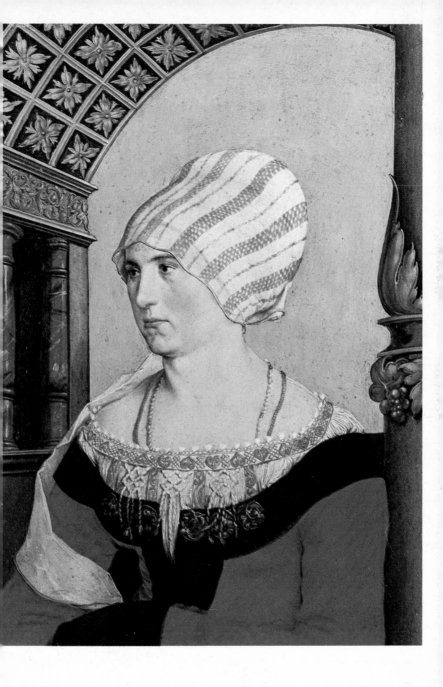

Signboard of the Schoolmaster Oswald Myconius (No. 12B).

Painted for the theologian and Latinist, Myconius, who moved from Lucerne to Basel in 1510. Myconius possessed a copy of Erasmus's PRAISE OF FOLLY *with marginal illustrations by Holbein. The co-operation of Holbein's brother, Ambrosius, has been postulated.*

wer jemand hie der gern u
Kützisten grundt den jeman
buchstaben kan der mag kün
mag von jm selber lernen si
tut gelernnen kan so unge
geben gelert haben und
wer er well · burger ou
nckfrouwen · wer sin be
gelert um ein zimlichen
lin noch den fronuaster

ernen dutſch ſchriben · vnd läſen vß dem aller

icken kan do durch ein jedz der vor nit ein

vnd bald begriffen ein grundt Do durch er

uld vff ſchriben vnd läſen · vnd wer es

kt were Den will ich vm̄ nüt vnd ve

tz nüt von jm zů lon nemen er ſyg

)andtwerckß geſellen frowen vnd ju

ff · Der kum har jn · der wirt drüwlich

· Aber die jungen knaben vnd mei

ie gewonheyt iſt · Anno · m cccc xv

6 The Agony in the Garden
Oil and tempera on canvas/
132.5 × 132.5/*c.* 1515–16
Basel, Öffentliche
Kunstsammlung

7 The Betrayal
Oil and tempera on canvas/
132.5 × 164.5/*c.* 1515–16
Basel, Öffentliche
Kunstsammlung

8 Christ before Pilate
Oil and tempera on canvas/
133.5 × 155.5/*c.* 1515–16
Basel, Öffentliche
Kunstsammlung

*Signboard of the Schoolmaster
Oswald Myconius (No. 12A;
detail).*

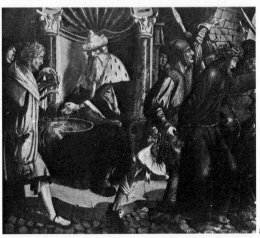

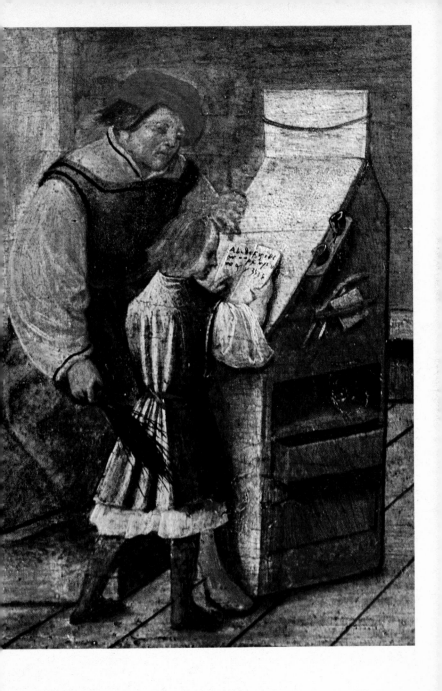

9 The Flagellation
Oil and tempera on canvas/
137 × 115/*c.* 1515–16
Basel, Öffentliche
Kunstsammlung

*

10 Jakob Meyer
Oil and tempera on wood/
38.5 × 31/s.d. 1516
Basel, Öffentliche
Kunstammlung
Pendant to No. 11
10a Preparatory drawing
Windsor Castle, Royal
Collection

11 Dorothea Kannengiesser,
wife of Jakob Meyer
Oil and tempera on wood/
38.5 × 31/1516
Basel, Öffentliche
Kunstsammlung
Pendant to No. 10
11a Preparatory drawing
Windsor Castle, Royal
Collection

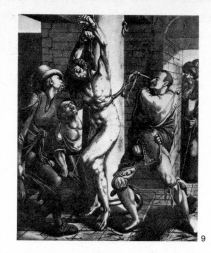

9

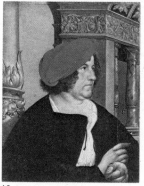

10

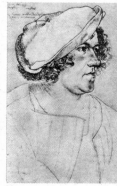

10a

11

11a

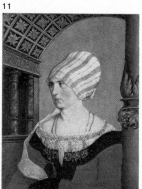

A Young Woman (No. 17;
detail).
Sometimes identified as
Holbein's wife, the identity of
the sitter has yet to be
established. The influence of
Leonardo is apparent.

18

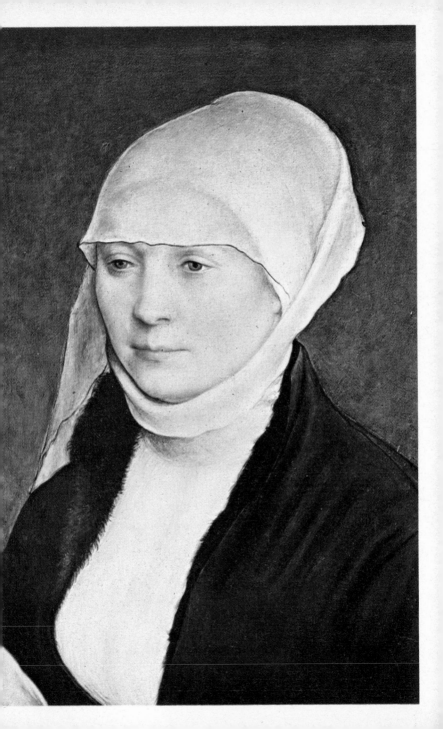

SIGNBOARD

12A Signboard of the
Schoolmaster Oswald
Myconius
Oil and tempera on wood/
55.5 × 65.5/d. 1516
Basel, Öffentliche
Kunstsammlung
Originally obverse of
No. 12B, from which it was
later cut out

12B Signboard of the
Schoolmaster Oswald
Myconius
Oil and tempera on wood/
55.5 × 65.5/d. 1516
Basel, Öffentliche
Kunstsammlung
Originally reverse of
No. 12A, from which it was
later cut out

13 Hans Herbster
Oil and tempera on paper
mounted on wood/
39.5 × 26.5/d. 1516
Basel, Öffentliche
Kunstsammlung
Attributed work (possibly by
Ambrosius Holbein)

14 Young Woman
Oil and tempera on paper/
27.2 × 18.8/c. 1516
Basel, Öffentliche
Kunstsammlung,
Kupferstichkabinett
Unfinished

15 Adam and Eve
Oil and tempera on paper
mounted on wood/30 × 35.5/
s.d. 1517
Basel, Öffentliche
Kunstsammlung

16 Benedikt von Hertenstein
Oil and tempera on paper
mounted on wood/
52.7 × 39.4/s.d. 1517
New York, Metropolitan
Museum of Art

17 Young Woman
Oil and tempera on wood/
45 × 34/c. 1517
The Hague, Mauritshuis

12A

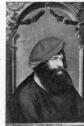

12B

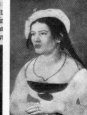

13

14

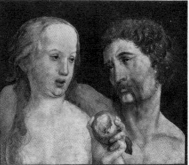

15

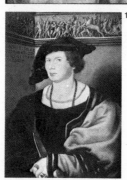

16

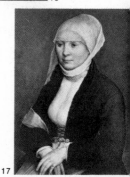

17

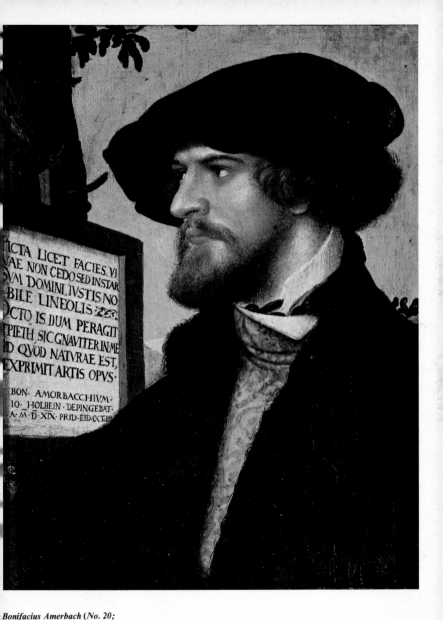

On the tablet:

ICTA LICET FACIES VI
VAE NON CEDO SED INSTAR
VM DOMINI IVSTIS NO
BILE LINEOLIS
CTO IS DUM PERAGIT
PIETH SIC GNAVITER IN ME
D QVOD NATVRAE EST,
EXPRIMIT ARTIS OPVS

BON · AMORBACCHIVM
IO · HOLBEIN · DEPINGEBAT ·
A · M · D · XIX · PRID · EID · OCTOB

***Bonifacius Amerbach (No. 20;
detail).***
*The tablet hung upon the tree
to the left praises the
verisimilitude of the portrait.
Humanist and friend of
Erasmus, Amerbach saved
many of Holbein's works
during the iconoclastic period.*

21

The Oberreid Altarpiece: The Adoration of the Shepherds *(No. 25A)* ***and*** ***The Adoration of the Magi*** *(No. 25B).*
The altarpiece, which survived the iconoclastic outbreaks, probably centred either on a painting or a sculptured group. It was commissioned by the councillor, Hans Oberreid, who came to Basel as a merchant but left during the Reformation. Both wings of the diptych are inspired by compositions by Hans Baldung.

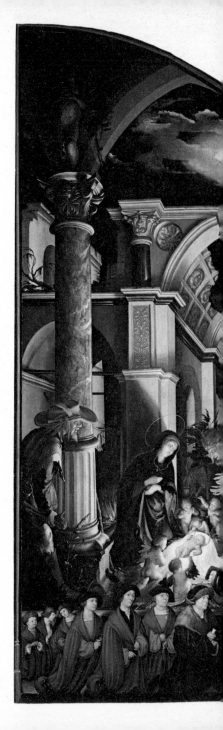

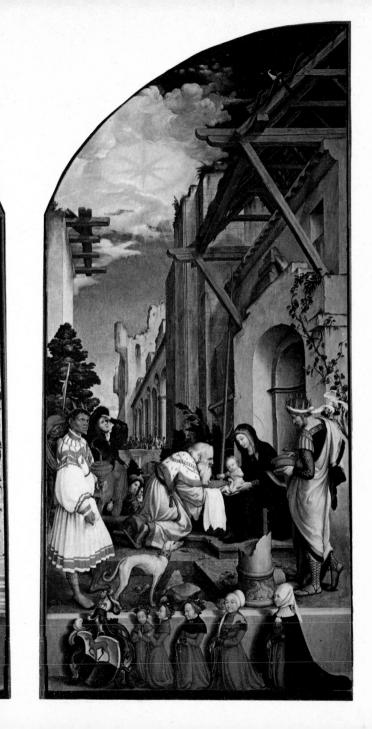

MURALS FOR THE HERTENSTEIN HOUSE, LUCERNE

Lost work known from a fragment, two autograph drawings and a reconstruction

18A The Death of Lucretia: Collatinus, Lucretia's husband
Oil on dry ground/136 × 65/ 1517–19
Lucerne, Kunstmuseum
Fragment

18b Leaina before the Judges
Basel, Öffentliche Kunstsammlung, Kupferstichkabinett
Preparatory drawing for the lost mural

18c Design for the decoration of the entrance porch and staircase
Basel, Öffentliche Kunstsammlung, Kupferstichkabinett

18d A. Landerer, Reconstruction of the exterior decoration of the Hertenstein House
Basel, Öffentliche Kunstsammlung, Kupferstichkabinett

19 Polyptych with 'Stories' of Christ
1518–19
Formerly in the St Francis or 'Barfüsser' Church, Lucerne
Two panels – Christ on the Cross between Mary and John (No. 19a), The Descent from the Cross (No. 19b) – are known from copies (respectively in Basel, Öffentliche Kunstsammlung, and in Palermo)

Christ in the Sepulchre (No. 26; detail).
A subject treated by Grünewald and Mantegna. Holbein does not soften the brutality by adding mourners but reduces it to a dispassionate scientific study of a corpse.

24

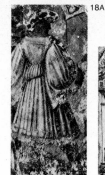
18A

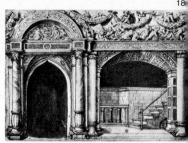
18

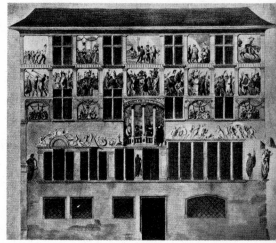
18d

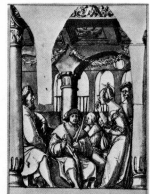
18b

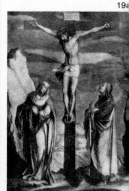
19a

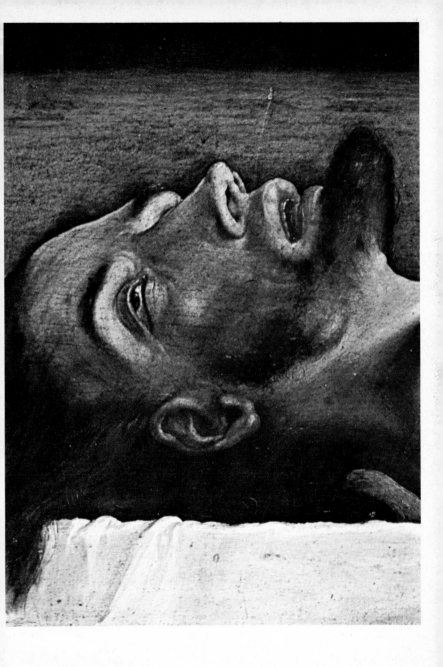

20 Bonifacius Amerbach
Oil and tempera on wood/
28.5 × 27.5/s.d. 1519
Basel, Öffentliche
Kunstsammlung

**DIPTYCH WITH CHRIST
AND THE VIRGIN**
21A The Man of Sorrows
Oil and tempera on wood/
29 × 19.5/c. 1520
Basel, Öffentliche
Kunstsammlung
Left panel
21B Mater Dolorosa
Oil and tempera on wood/
29 × 19.5/c. 1520
Basel, Öffentliche
Kunstsammlung
Right panel

22 Hans of Zurich
c. 1520
Lost work known from an
engraving by W. Hollar
(No. 22a)

**23 Paintings for the façades
of the House of the Dance**
c. 1520
Lost work known from a
reconstruction by W. Spiess
(1878, Basel, Historisches
Museum, No. 23a) and two
copies of designs for the
decoration

24 The Judgement of Solomon
Oil and tempera on wood/
58 × 45/c. 1521–2
Basel, Öffentliche
Kunstsammlung
Attributed work

**Virgin and Child with Saints
(No. 39).**
*Heavily influenced in its
architectural setting and
perspective by Italian
Renaissance altarpieces, this
painting presents many
problems. The carpet has been
interwoven with the arms of
Johannes Gerster, secretary of
Basel, and his wife, Barbara
Guldenknopf, who
commissioned it.*

26

19b

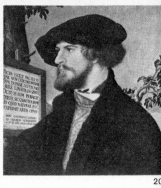
20

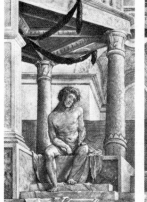
21A

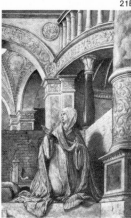
21B

23a

22a

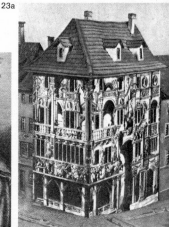

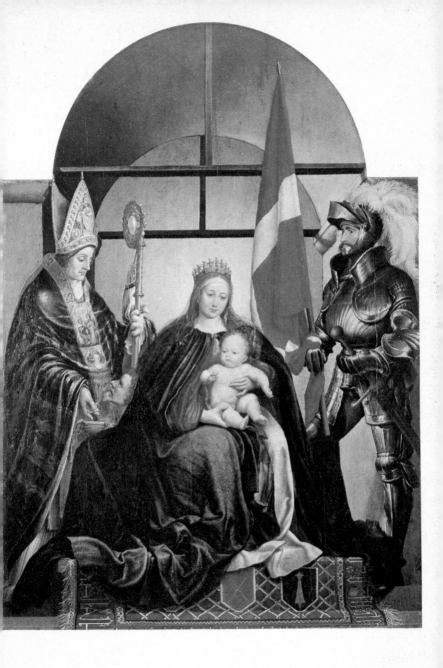

THE OBERREID ALTARPIECE

25A The Adoration of the Shepherds
Oil and tempera on wood/
231 × 109/1521–2
Freiburg, Cathedral,
University Chapel
Inner left panel

25B The Adoration of the Magi
Oil and tempera on wood/
230 × 110/1521–2
Freiburg, Cathedral,
University Chapel
Inner right panel

26 Christ in the Sepulchre
Oil and tempera on wood/
30.5 × 200/s.d. 1522
Basel, Öffentliche
Kunstsammlung

PAINTINGS IN THE GREAT COUNCIL CHAMBER OF BASEL TOWN HALL

27 The Death of Charondas
Fresco/1521–2
Two fragments are extant in
Basel, Öffentliche
Kunstsammlung (Head of
Charondas, No. 27A, and
Frightened Spectator,
No. 27B)

28 The Samnite Ambassadors before Marcus Curtius Dentatus
Fresco/1521–2
A fragment (No. 28A) is
extant in Basel, Öffentliche
Kunstsammlung. A copy of
the painting by J. Hess is also
known

29 King Rehoboam rebuking the Elders of Israel
Fresco/1530
Seven fragments
(Nos. 29A–G) are extant in
Basel, Öffentliche
Kunstsammlung as well as a
drawing (No. 29a) by
Holbein (Basel, Öffentliche
Kunstsammlung)

30 Justice warns the Council
Fresco
Lost work known from a
copy after a drawing by
Holbein

24

29A

29B

29C

29D

29E

29F

29G

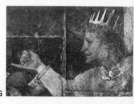

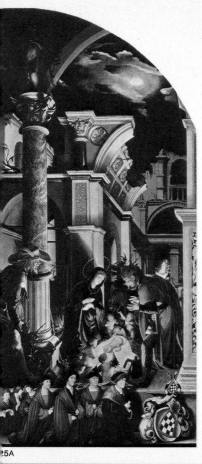

25A

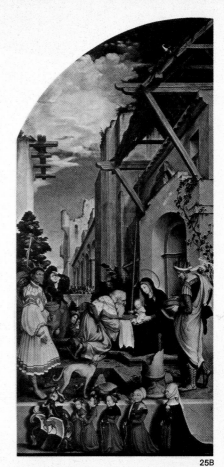

25B

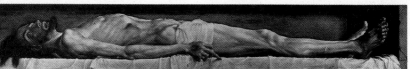

26c

28A

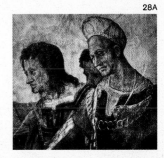

MORS. F

27A

27B

31 Wisdom
Fresco
Lost work known from a
copy after a drawing by
Holbein

32 Temperance
Fresco
Lost work known from a
copy after a drawing by
Holbein

33 King David
Fresco
Lost work known from a
copy after a drawing by
Holbein

34 Christ
Fresco
Lost work known from a
copy after a drawing by
Holbein

35 King Sapor humiliating the Emperor Valerian
Fresco
Lost work known from a
copy after a drawing by
Holbein

36 The Blinding of Zaleuccus
Fresco
Lost work known from a
copy after a drawing by
Holbein

37 The Meeting of Samuel and Saul
Fresco
Lost work known from a
drawing (No. 37a) by
Holbein (Basel, Öffentliche
Kunstsammlung)

38 Christ and the Woman taken in Adultery
Work not realized in fresco
and known from a copy after
a drawing by Holbein

*

39 Virgin and Child with Saints (The Solothurn Madonna)
Oil and tempera on wood/
140.5 × 102/s.d. 1522
Solothurn, Museum der Stadt

*Erasmus (No. 42; detail).
Erasmus, the humanist, was
one of Holbein's keenest
admirers. The painter has
depicted him in the tradition of
an evangelist penning the
gospels.*

30

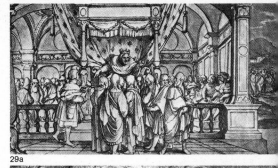

29a

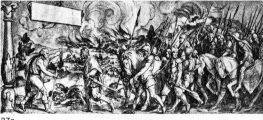

37a

39

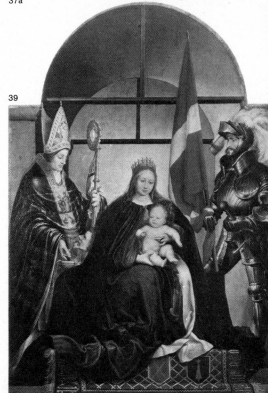

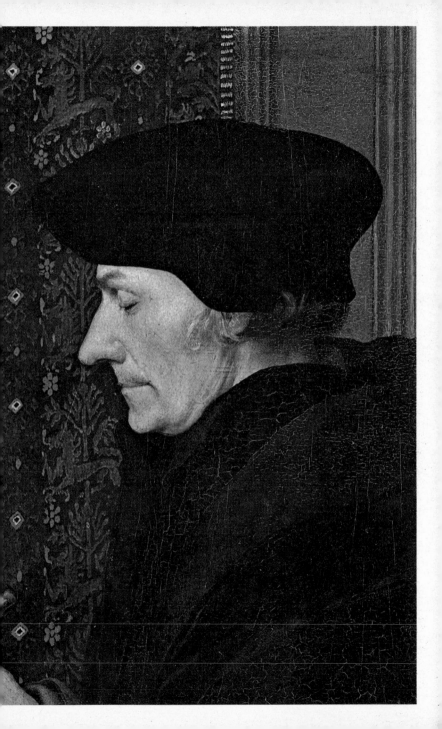

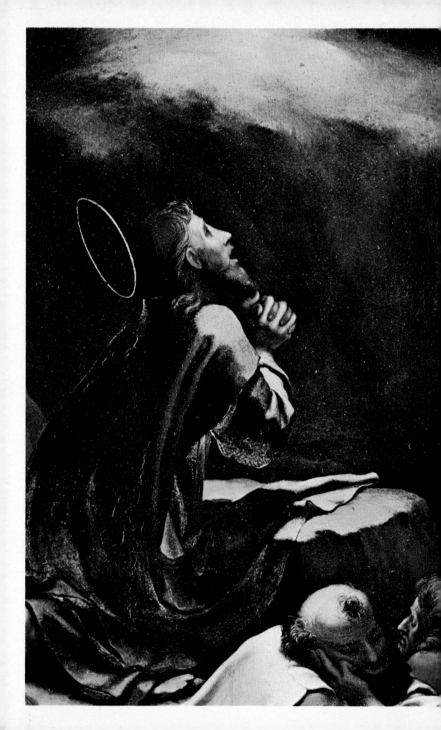

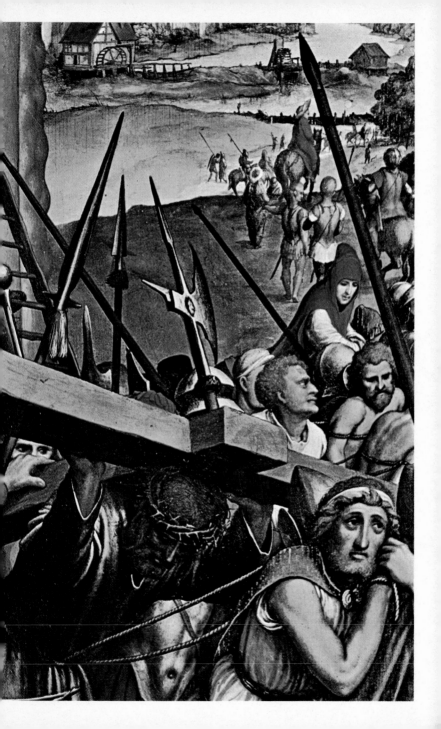

40 Johannes Froben
Oil and tempera on wood/
48.9 × 32.4/s./1522–3(?)
Hampton Court, Royal
Collection

41 Erasmus
Oil and tempera on wood/
76 × 51/s.d. 1523
Longford Castle, Earl of
Radnor
41a Preparatory study for the
right hand
Paris, Louvre, Cabinet des
Dessins

42 Erasmus
Oil and tempera on wood/
43 × 33/1523
Paris, Louvre
42a Study for the hands
Paris, Louvre, Cabinet des
Dessins

43 Erasmus
Oil and tempera on paper/
37 × 30.5/1523(?)
Basel, Öffentliche
Kunstsammlung

**44 Printer's Mark of Johannes
Froben**
Oil and tempera on canvas/
44 × 30.5/1523
Basel, Öffentliche
Kunstsammlung,
Kupferstichkabinett

45 St George
Oil and tempera on wood/
96.4 × 41.5/1523(?)
Karlsruhe, Staatliche
Kunsthalle
Pendant to No. 46
Attributed work

**The Passion Altarpiece: The
Agony in the Garden
(No. 47A) and Christ carrying
the Cross (No. 47B) (details).
(pp. 32–33)**
*These plates, as well as the
plates on pp. 36–7, are details
from the four panels of an
altarpiece depicting the
Passion, possibly originally for
the cathedral at Basel and
rescued during the iconoclastic
storms. They are strong in
Italian influences from
Mantegna (Caiaphas
enthroned and the warrior with
the spear in the CRUCIFIXION)
and Raphael (the
ENTOMBMENT).*

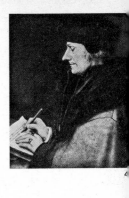

40

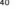

41a

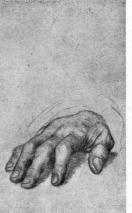

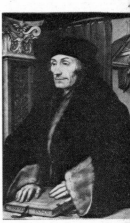

42a

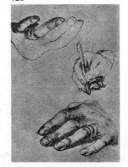

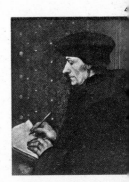

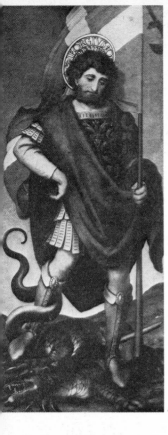

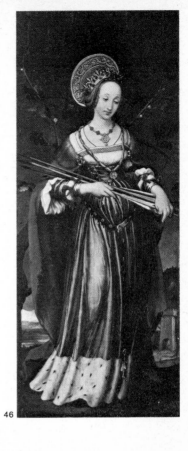

45

46

44

48

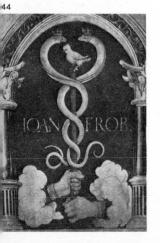

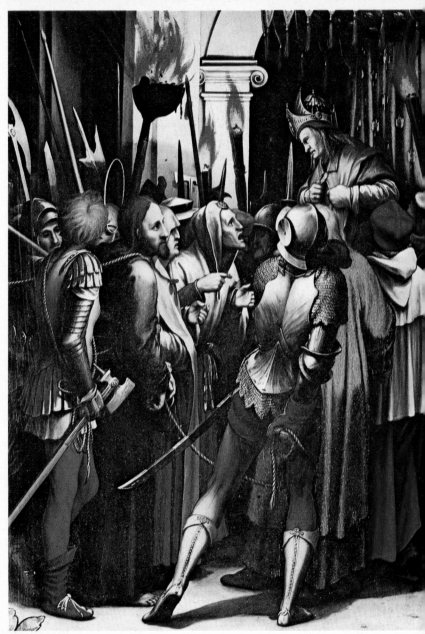

The Passion Altarpiece:
Christ before Caiaphas
(*No. 47C; detail*) *and The*
Entombment (*No. 47D;*
detail).

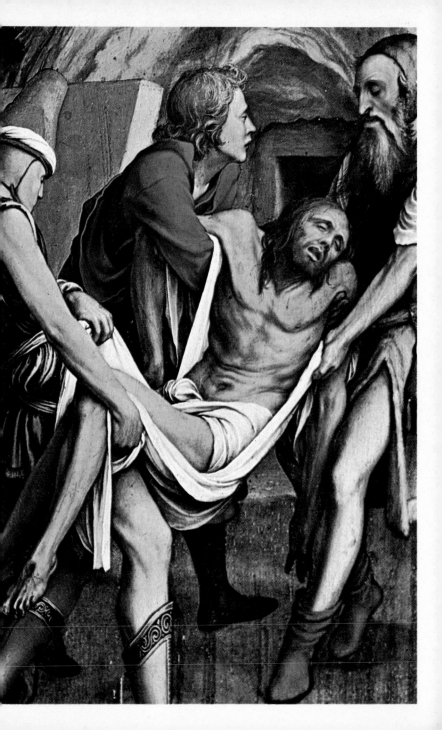

46 St Ursula
Oil and tempera on wood/
96.4 × 41.9/s.d. 1523(?)
Pendant to No. 45
Attributed work

PASSION ALTARPIECE
1524(?)
Basel, Öffentliche
Kunstsammlung
47A The Agony in the Garden.
Christ crowned with Thorns
Oil and tempera on wood/
136.5 × 31
47B The Betrayal. Christ
carrying the Cross
Oil and tempera on wood/
149.5 × 31
47C Christ before Caiaphas.
The Crucifixion
Oil and tempera on wood/
149.5 × 31
47D The Scourging of Christ.
The Entombment
Oil and tempera on wood/
136 × 31

48 Allegory of the Old and
New Testaments
Oil and tempera on wood/
49 × 60/1524–5(?)
Ince Blundell Hall, Weld
Collection
Attributed Work

49 The Last Supper
Oil and tempera on wood/
115.5 × 97.5/1524–6(?)
Basel, Öffentliche
Kunstsammlung

ORGAN DOORS OF
BASEL MINSTER
50A The Emperor Henry II,
his wife Kunigunde and the
Minster of Basel
Oil and tempera on canvas/
244 × 62; 225, 142 and
282.5 × 165/c. 1525–6
Basel, Öffentliche
Kunstsammlung
Inside of the left shutter
50B The Virgin and Child, St
Pantalus and Angel Musicians
Oil and tempera on canvas/
285.5 × 142.5 and 224 × 165;
243.5 × 62.5/c. 1525–6
Basel, Öffentliche
Kunstsammlung
Inside of the right shutter

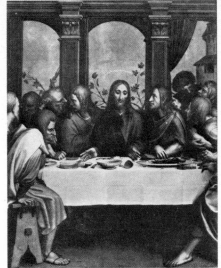

49

50A 50

51 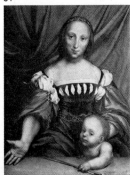 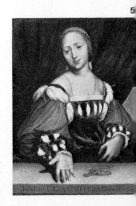 5

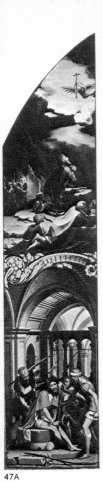

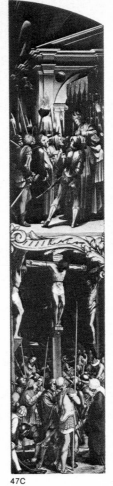

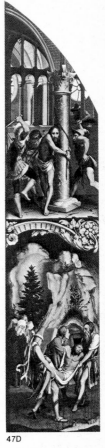

47A 47B 47C 47D

53a

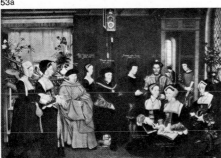

53b

51 Venus and Cupid
Oil and tempera on wood/
34.5 × 26/1526(?)
Basel, Öffentliche
Kunstsammlung

52 Lais of Corinth
Oil and tempera on wood/
35.6 × 26.7/d. 1526
Basel, Öffentliche
Kunstsammlung

**THE FAMILY OF SIR
THOMAS MORE**
1526–7
Lost work known from
several drawings (listed
below) and a copy
**53a Copy of the painting by
R. Locky** (Nostell Priory,
Collection of the Trustees of
the late Lord St Oswald)
**53b Drawing after the
painting**
Basel, Öffentliche
Kunstsammlung
**53c Drawing of Elizabeth
Dauncey**
Windsor Castle, Royal
Collection
**53d Drawing of Margaret
Giggs**
Windsor Castle, Royal
Collection
**53e Drawing of Sir John
More**
Windsor Castle, Royal
Collection
**53f Drawing of Anne
Cresacre**
Windsor Castle, Royal
Collection
**53g Drawing of Sir Thomas
More**
Windsor Castle, Royal
Collection
**53h Drawing of John More
the Younger**
Windsor Castle, Royal
Collection
53i Drawing of Cecily Heron
Windsor Castle, Royal
Collection

*

54 Lady with a Squirrel
Oil and tempera on wood/
54 × 38.7/c. 1526–8
Houghton Hall,
Cholmondeley Collection

40

53c

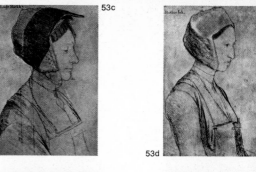
53d

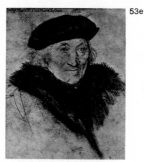
53e

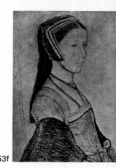
53f

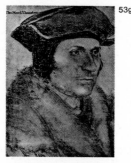
53g

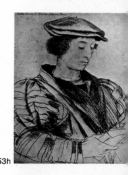
53h

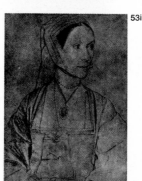
53i

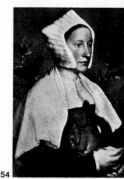
54

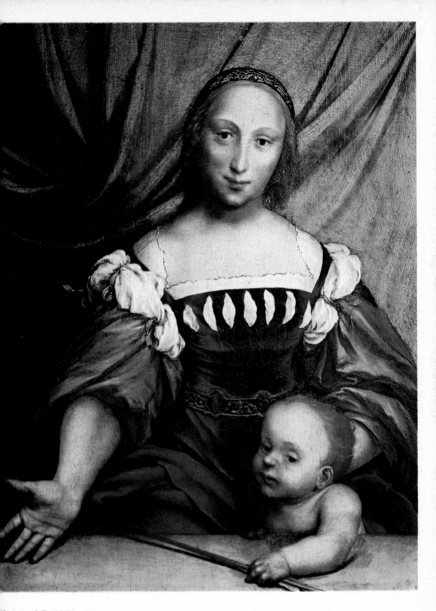

Venus and Cupid (*No. 51*)
The treatment of the figure and especially the facial type betray the influence of the Leonardesque. Both the dating and its exact relationship to the LAIS OF CORINTH *(No. 52) are subject to controversy.*

41

55 Virgin and Child with Donors
(The Darmstadt Madonna)
Oil and tempera on wood/
146.5 × 102/1526–30
Darmstadt, Grand-ducal
Palace

56 Sir Thomas More
Oil and tempera on wood/
75 × 60.5/d. 1527
New York, Frick Collection

57 Alice Middleton, Lady More
Oil and tempera on wood/
36.6 × 26.9/1527
Corsham Court, Methuen
Collection

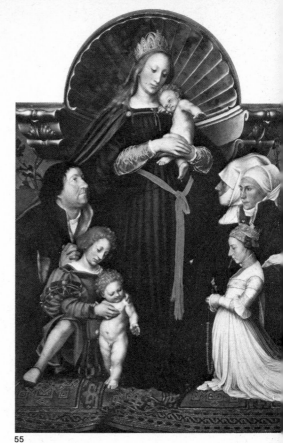

55

56

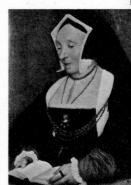

5

Virgin and Child with Donors (No. 55; detail).
The group is of the two wives and daughter of the commissioner, Jakob Meyer: his first wife, Magdalen Baer, his second, Dorothea Kannengiesser, and their daughter, Anna.

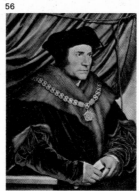

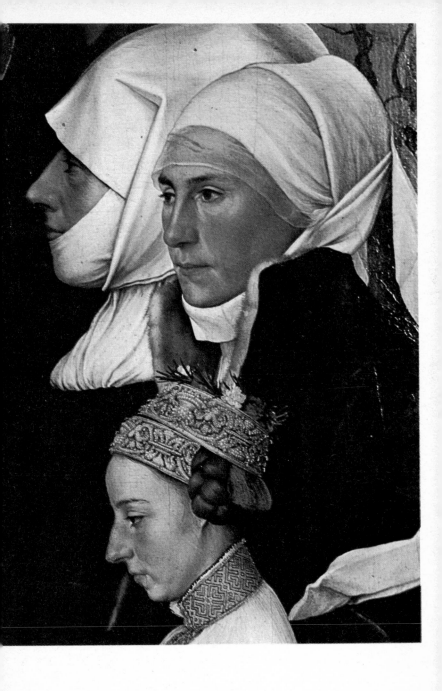

58 William Warham,
Archbishop of Canterbury
Oil and tempera on wood/
82 × 66/d. 1527
Paris, Louvre
A preparatory drawing is
known (Windsor Castle,
Royal Collection, No. 58a)
as well as two versions
(London, Lambeth Palace,
No. 58b, and National
Portrait Gallery, No. 58c)

59 Sir Henry Guildford
Oil and tempera on wood/
81.4 × 66/d. 1527
Windsor Castle, Royal
Collection
Pendant to No. 60
59a Preparatory drawing
Windsor Castle, Royal
Collection

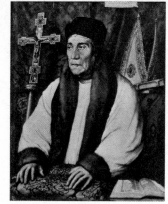

58

58a

58b

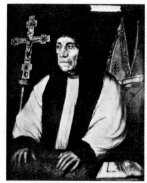

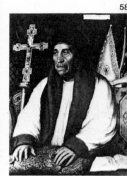

58

59

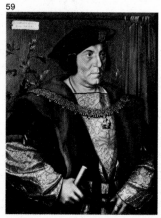

Sir Thomas More (No. 56,
detail).
Holbein's supreme surviving
masterpiece from his first
English period during which he
worked in the household of Sir
Thomas More. X-rays show
changes made during the
painting confirming the
primacy of the picture,
although its history before
1858 is tenuous. The collar of
SS establishes More's role as
a servant of the king and the
paper as a man of affairs.

59

44

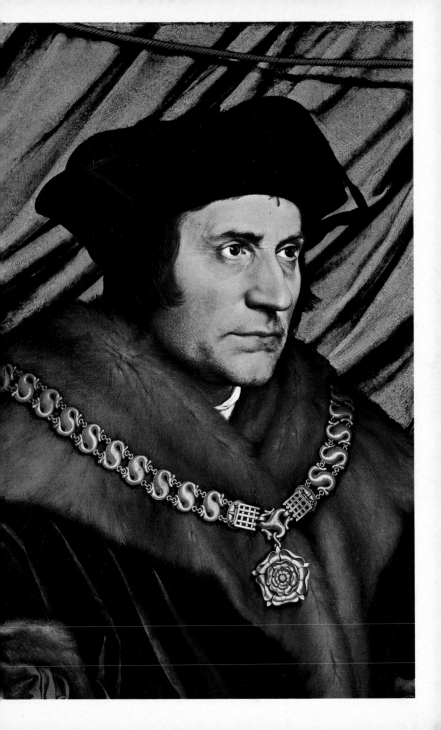

60 Mary Wotton, Lady Guildford
Oil and tempera on wood/
80 × 65/d. 1527
St Louis, City Art Museum
Pendant to No. 59
60a Preparatory drawing
Basel, Öffentliche
Kunstsammlung,
Kupferstichkabinett

61 Sir Henry Wyatt
Oil and tempera on wood/
39 × 31/c. 1527
Paris, Louvre

62 Nikolaus Kratzer
Oil and tempera on wood/
83 × 67/d. 1528
Paris, Louvre
An early version is known
(UK, Private Collection)

63 Thomas and John Godsalve
Oil and tempera on wood/
35 × 36/d. 1528
Dresden, Gemäldegalerie Alte
Meister

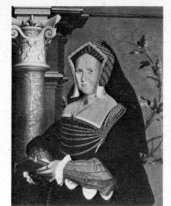
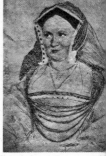

60

6

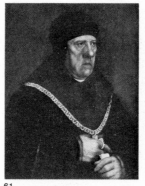
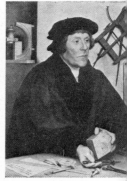

61

6

William Warham, Archbishop of Canterbury (No. 58).
The formula of placing the sitter behind a table or ledge is typically northern European from the previous century and Warham's status is defined by his coat of arms, crucifix and mitre. The breviary is open at the litany of the saints.

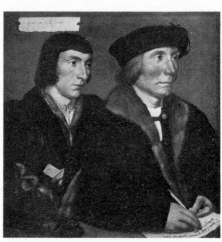

63

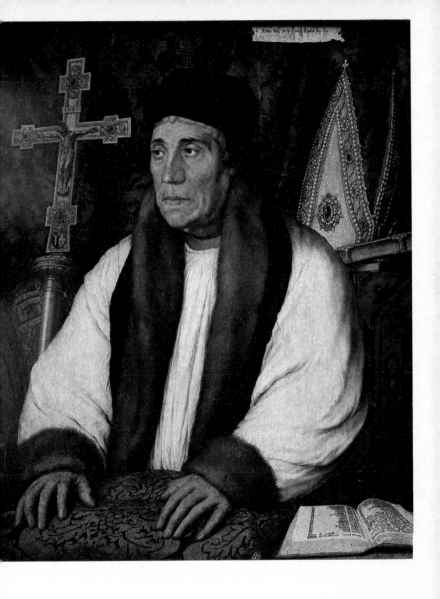

64 Holbein's Wife and Two Children
Oil and tempera laid on wood/77 × 64/d. 1528
Basel, Öffentliche Kunstsammlung
Two versions are known (Switzerland, Private Collection, No. 64a, and Lille, Musée des Beaux-Arts, No. 64b)

CAPSULE
65A Philip Melanchthon
Oil and tempera on wood/diam. 9/c. 1530
Hanover, Niedersächsische Landesgalerie
Bottom of the capsule
65B Inside of the lid of the capsule
Oil and tempera on wood/diam. 12/c. 1530
Hanover, Niedersächsische Landesgalerie
In the middle the inscription: 'QVI CERNIS TANTUM NON, VIVA MELANTHONIS ORA, HOLBINVS RARA DEXTERITATE DEDIT'.

Sir Henry Guildford (No. 59; detail).
Guildford was Comptroller of the Royal Household and a favourite of Henry VIII. As Chamberlain of the Exchequer he authorized payments for Holbein's work in connection with the temporary banqueting house at Greenwich in 1527. The collar and badge of St George and the Dragon are those of the Order of the Garter to which Guildford was elected in 1526; they show Holbein's ability to delineate things seen with an almost photographic realism.

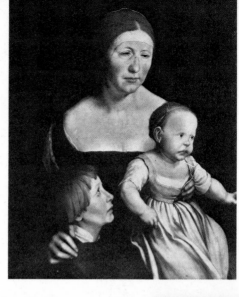

64

64a

6

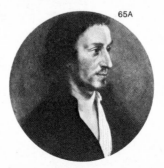

65A

6

48

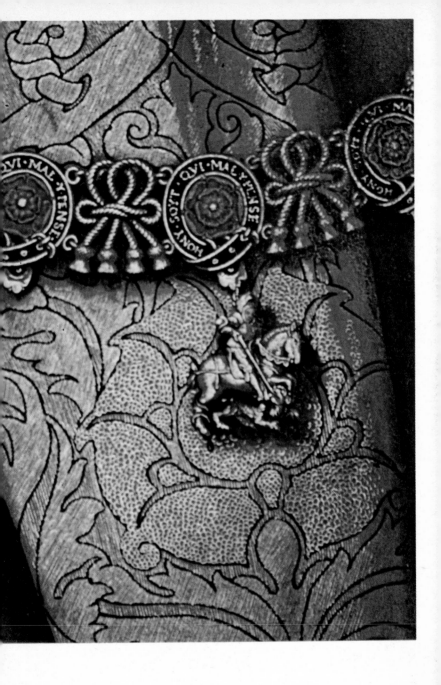

49

66 Erasmus
Oil and tempera on wood/
33 × 25/d. 1530
Parma, Galleria Nazionale
Early version of No. 41, of
which other versions are
known (Zürich, Private
Collection; New York,
Metropolitan Museum of
Art; Paris, Rothschild
Collection, and Basel,
Öffentliche Kunstsammlung)

67 George Gisze
Oil and tempera on wood/
96.3 × 85.7/d. 1532
Berlin-Dahlem, Staatliche
Museen, Gemäldegalerie

**68 Unknown Man called Hans
of Antwerp**
Oil and tempera on wood/
60 × 45/d. 1532
Windsor Castle, Royal
Collection

69 Hermann Wedigh
Oil and tempera on wood/
41.9 × 31.8/s.d. 1532
New York, Metropolitan
Museum of Art

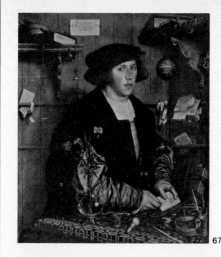

67

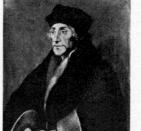

66

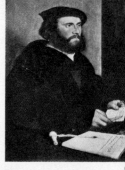

6

**Mary Wotton, Lady Guildford
(No. 60).**
*Companion portrait to the one
of her husband (No. 59), the
sitter is placed in relation to
architecture in a classical style
at that time virtually unknown
in England but frequently
included by Holbein in his
early portraits. The foliage,
carefully arranged in an
arabesque, is also a feature of
portraits during these years.*

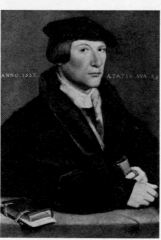

69

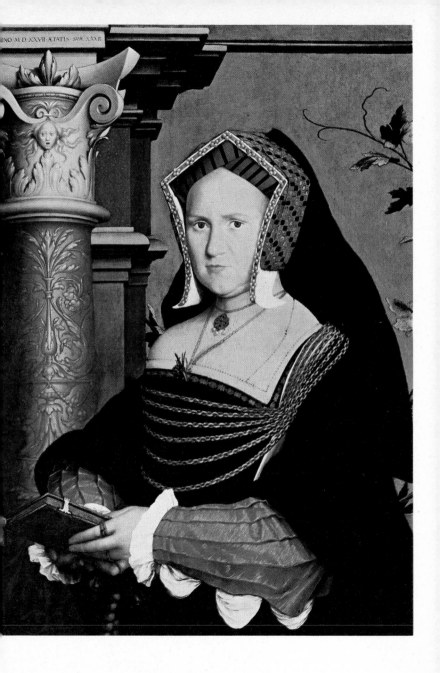

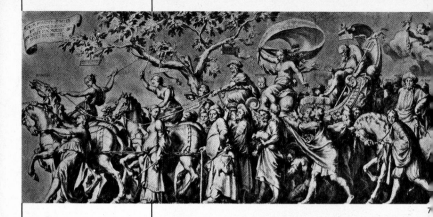

70

WALL PAINTINGS FOR THE BANQUETING HALL OF THE GUILDHALL OF THE STEELYARD, LONDON

70 The Triumph of Riches
Oil on canvas/244 × 616/
1532(?)
Lost work known from a
preparatory drawing,
No. 70a (Paris, Louvre) and
a copy by J. Bisschop, *c.* 1670
(London, British Museum)

71 The Triumph of Poverty
Oil on canvas/222 × 301/
1532(?)
Lost work known from a
copy by J. Bisschop, *c.* 1670,
No. 71a (London, British
Museum)

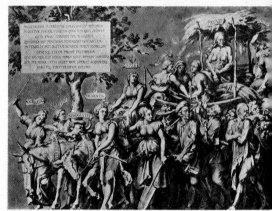

71a

*

72 Noli me tangere
Oil and tempera on wood/
76.7 × 95.2/*c.* 1532–3
Hampton Court, Royal
Collection
Recent studies indicate also
c. 1524 for this work

***Nikolaus Kratzer (No. 62,
detail).***
*Kratzer, mathematician and
astronomer, was in royal
service by 1520. In this detail
the sitter is shown holding a
pair of dividers and an
unfinished polyhedral dial, the
gnomons for which lie on the
table.*

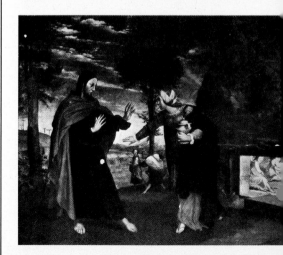

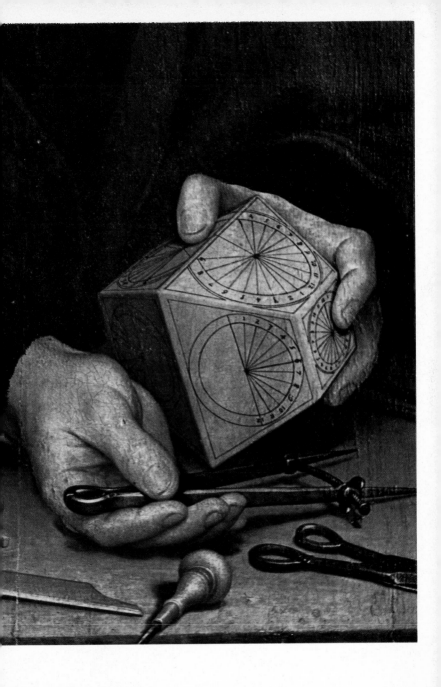

Thomas and John Godsalve (No. 63; detail).
Thomas Godsalve was a friend of Thomas Cromwell, through whose influence his son became Clerk of the Signet. The double portrait formula of father and son is unique among Holbein's oeuvre.

Anno·Dni·M·D·xxviij

73 William Reskimer of Murthyr
Oil and tempera on wood/
44.5 × 31.7/1532–3
Windsor Castle, Royal
Collection
73a Preparatory drawing
Windsor Castle, Royal
Collection

74 Sir Nicholas Carew
Oil and tempera on wood/
91.3 × 101.7/*c.* 1532–3
Drumlanrig Castle,
Collection of the Duke of
Buccleuch and Queensberry
74a Preparatory drawing
Basel, Öffentliche
Kunstsammlung

75 Portrait of a Man
Oil and tempera on wood/
diam. 13/1532–3
London, Victoria and Albert
Museum
Attributed work

76 Portrait of a Man
Oil and tempera on wood/
diam. 10.4/1532–3
Private Collection
Attributed Work

73

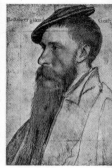
73a

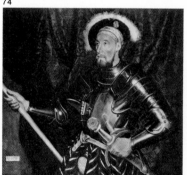
74

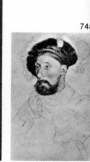
74a

Holbein's Wife and Two Children (No. 64).
Elsbeth Binsenstock, who married Holbein in 1519, is depicted with her son, Philip, by her side and her daughter, Katharine, on her knee. The iconographic formula is that of a Virgin and Child with the Infant St John.

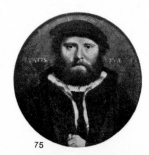
75 76

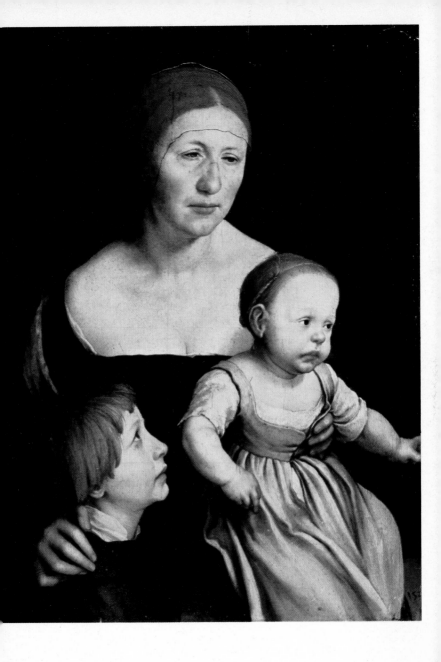

77 *Woman in a White Coif*
Oil and tempera on wood/
23.4 × 18.8/1532–4
Detroit, Ford Collection
Attributed Work

78 *Portrait of a Man*
Oil and tempera on wood/
diam. 9.8/1532–5
Florence, Uffizi
Attributed work

79 *Derich Born*
Oil and tempera on paper
mounted on wood/
diam. 10.2/1533(?)
Munich, Alte Pinakothek
Attributed work

80 *Young Man*
Oil and tempera on wood/
diam. 12.5/d. 1533
Upton House, National Trust
Attributed work

**81 *Hermann Hillebrandt
Wedigh***
Oil and tempera on wood/
39 × 30/d. 1533
Berlin-Dahlem, Staatliche
Museen, Gemäldegalerie

82 *Dirk Tybis*
Oil and tempera on wood/
48 × 35/d. 1533
Vienna, Kunsthistorisches
Museum

*George Gisze (No. 67; detail).
Gisze was a Hanseatic
merchant whose family came
from Cologne. The
preoccupation with a finite
setting and with a multitude of
attributes reaches a climax in
this portrait and that of* THE
AMBASSADORS *(No. 86)
painted the following year.*

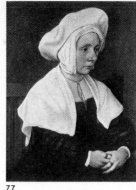

77

78

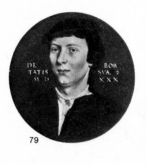

79

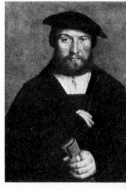

82

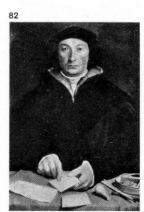

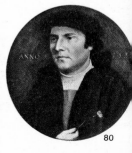

80

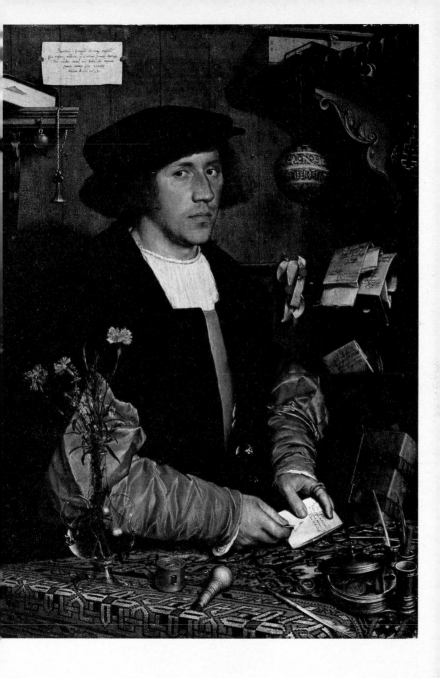

Noli me tangere (No. 72).
There is no record of this
painting in the Royal
Collection until 1680 and it
was first attributed to Holbein
in 1895. In style it relates to
the period of the artist's visit
to France and shows the
influence of both Baldung and
Burgkmair combined, in
particular in the figure of the
Magdalene, with echoes of
Italian High Renaissance
painting.

83 Cyriakus Kale
Oil and tempera on wood/
60 × 44/d. 1533
Braunschweig, Herzog Anton
Ulrich Museum

84 Derich Born
Oil and tempera on wood/
60.3 × 45/d. 1533
Windsor Castle, Royal
Collection

85 Robert Cheseman
Oil and tempera on wood/
59 × 62.5/d. 1533
The Hague, Mauritshuis

**86 Jean de Dinteville and
Georges de Selve ('The
Ambassadors')**
Oil and tempera on wood/
207 × 209/s.d. 1533
London, National Gallery

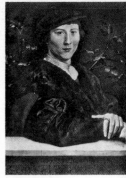

83 84

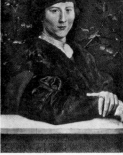

85

86

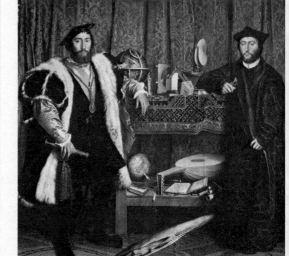

*Sir Nicholas Carew (No. 74;
detail)*
*Carew was Master of the
Horse to Henry VIII, although
he later fell from favour and
was executed in 1539. The
picture is one of the most
problematic. Its ceremonial
concept is close in mood to
that of* THE AMBASSADORS
(No. 86).

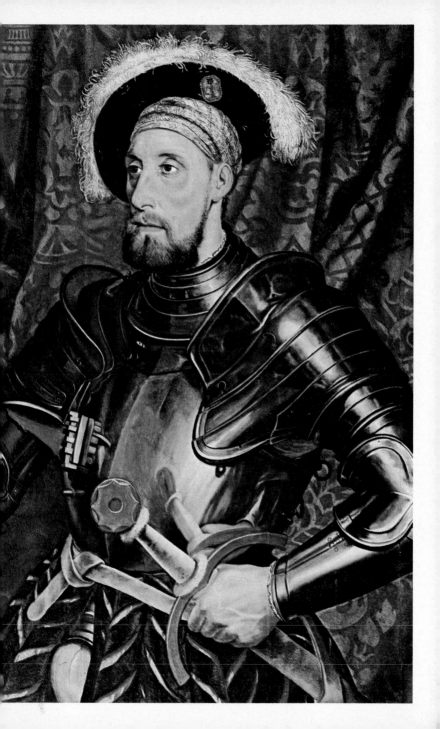

87 George Neville, Lord Abergavenny
c. 1533
Lost work known from a drawing, No. 87a (Wilton House, Earl of Pembroke) and an early version, No. 87b (New York, Erikson Collection)

88 Margaret, Marchioness of Dorset
c. 1533–4
Lost work known from a drawing (Windsor Castle, Royal Collection) and two early versions (for both, location unknown)

89 Richard Mabon
Oil and tempera on wood/ 45.7 × 34/1533–4
Amsterdam, Rijksmuseum
Attributed work

90 Official of the Court of Henry VIII
Oil and tempera on wood/ diam. 12/1534
Vienna, Kunsthistorisches Museum
Pendant to No. 91
Attributed work

91 Wife of an Official of the Court of Henry VIII
Oil and tempera on wood/ diam. 12/1534
Vienna, Kunsthistorisches Museum
Pendant to No. 90
Attributed work

Robert Cheseman (No. 85; detail).
Robert Cheseman of Dormanswell was of gentry stock. His father was Justice of the Peace for Middlesex. The horizontal format of the portrait reflects the experimentation typical of the early years of Holbein's second English period. The obsession with attributes has been dropped, with the exception of the brilliantly observed falcon.

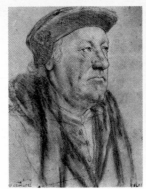

87a

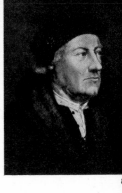
8

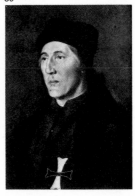
89

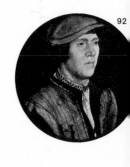
92

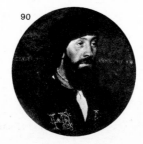
90

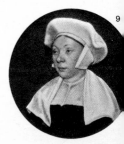
9

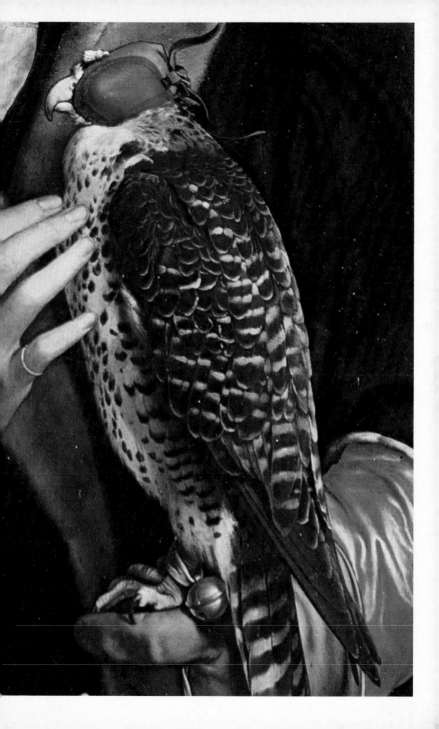

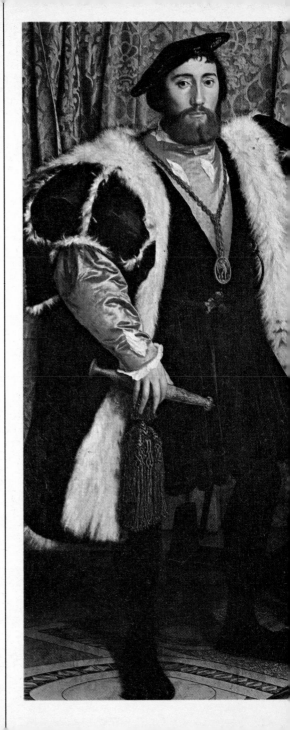

The Ambassadors (No. 86).
*Jean de Dinteville, Sieur de
Polisy, and Georges de Selve,
Bishop of Lavour, are
presented in Holbein's most
spectacular symbolic group
with elaborate allusions to the
whole range of humanist and
reformist principles at issue in
the 1530s. Dinteville was five
times ambassador in London.
The formula was repeated for
the figures of Henry VII and
Elizabeth of York in the
Whitehall wall-painting
(No. 110).*

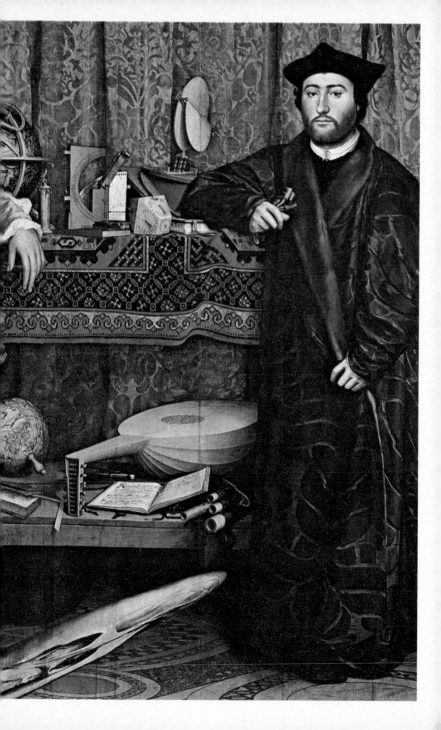

92 Official of the Court of Henry VIII
Oil and tempera on wood/ diam. 9.6/*c.* 1534
Thonon, Château de Ripaille, Engel Gros Collection
Attributed Work

93 Sir Henry Guildford
Oil and tempera on wood/ diam. 11.4/*c.* 1534
Detroit, Institute of Arts
Attributed work

94 Man with a Lute
Oil and tempera on wood/ 43.5 × 43.5/1534–5(?)
Berlin-Dahlem, Staatliche Museen, Gemäldegalerie
Attributed work

95 Charles de Solier, Sieur de Morette
Oil and tempera on wood/ 92.5 × 75.4/*c.* 1534–5
Dresden, Gemäldegalerie Alte Meister
95a Preparatory drawing
Dresden, Kupferstichkabinett

93

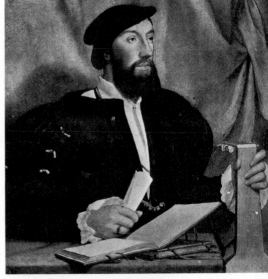

95

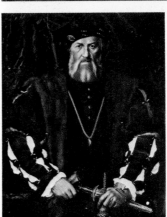

Charles de Solier, Sieur de Morette (No. 95).
Painted while Solier was ambassador from Francis I, the pose was re-used by Holbein in the famous Whitehall wall-painting for the figure of Henry VIII (No. 110).

68

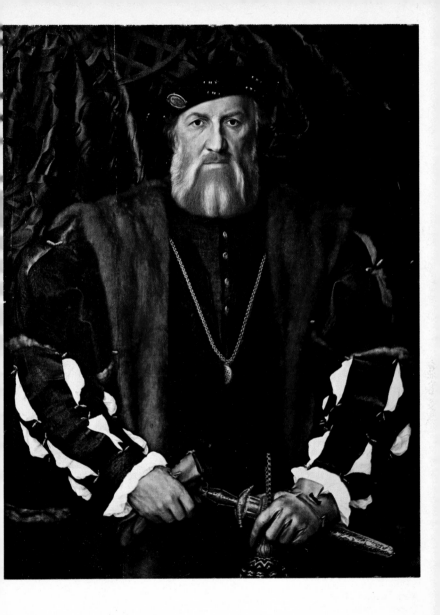

96 Thomas Cromwell, 1st Earl of Essex
c. 1534–5
Lost work known from several early versions (New York, Frick Collection, No. 96a; Burton Constable, Chichester-Constable Collection; London, National Portrait Gallery)

97 Simon George of Quotoule (or Quocote)
Oil and tempera on wood/ diam. 31/*c.* 1534–5
Frankfurt, Städelsches Kunstinstitut
97a Preparatory drawing
Windsor Castle, Royal Collection

98 Man with Gloves
Oil and tempera on wood/ diam. 30.5/d. 1535
New York, Metropolitan Museum of Art

99 Sir Nichols Poyntz
1535
Lost work known from a drawing (Windsor Castle, Royal Collection) and an early version (Sandon Hall, Earl of Harrowby)

100 Lady Elizabeth Vaux
c. 1535
Lost work known from a drawing, No. 100a (Windsor Castle, Royal Collection) and two early versions (Windsor Castle, Royal Collection, No. 100b; Prague, Naródní Galerie, No. 100c)

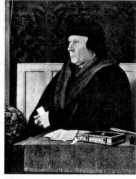

96a

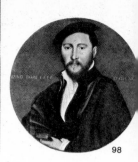

98

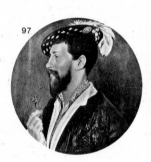

97

97

100a

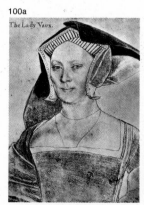

100

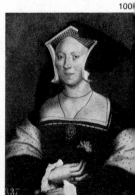

Simon George of Quotoule (or Quocote) (No. 97; detail).
The Georges were a Dorset family but Simon George settled at Quotoule in Cornwall. The portrait is an instance of Holbein's use of the classical medallic formula.

70

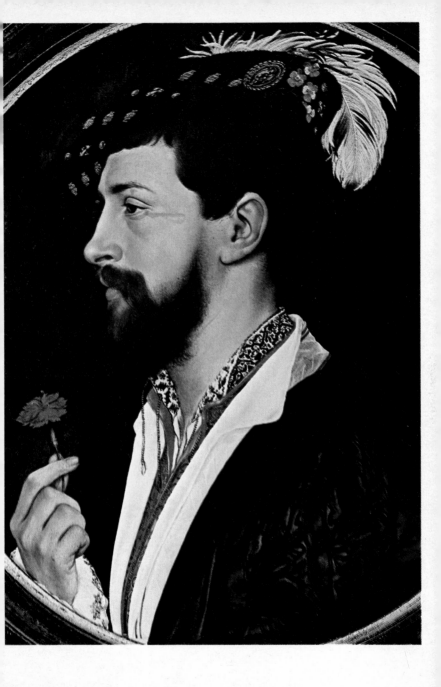

101 Derich Berck
Oil and tempera transferred
to canvas/53.3 × 42.6/d. 1536
New York, Metropolitan
Museum of Art

102 Sir Richard Southwell
Oil and tempera on wood/
47.5 × 38/d. 1536
Florence, Uffizi
A preparatory drawing is
known, No. 102a (Windsor
Castle, Royal Collection) as
well as an early version
(London, National Portrait
Gallery)

103 Sir Thomas Le Strange
Oil and tempera on wood/
39 × 26.7/1536
USA, Private Collection
103a Possible preparatory
drawing
Windsor Castle, Royal
Collection

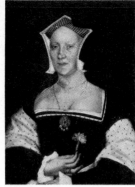

100c

10

102

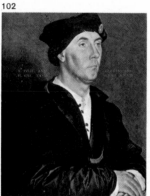

102

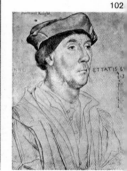

103

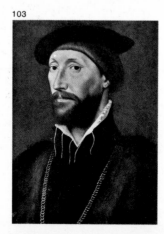

103a

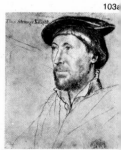

**Sir Richard Southwell
(No. 102).**
*Southwell, courtier and friend
of Thomas Cromwell, took an
active part in the Dissolution
of the Monasteries. The marks
on the sitter's mid-forehead,
nose and neck are wound
scars, evidence of Holbein's
extreme verisimilitude of
presentation.*

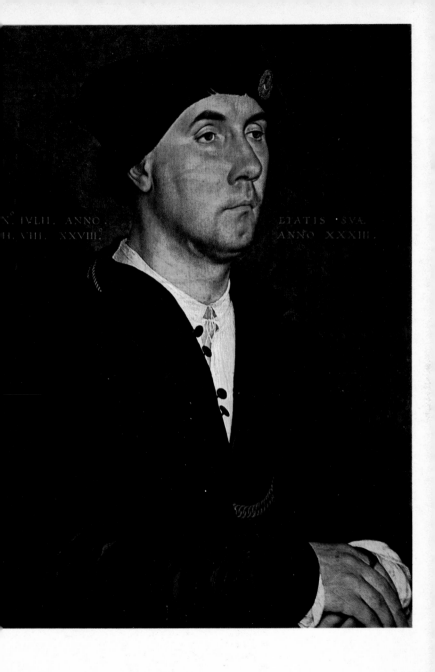

N. IVLII. ANNO .
H. VIII. XXVIII.

ETATIS ·SVA.
ANNO XXXIII.

104 John Godsalve
Oil and tempera on wood/
32.7 × 24.8/s./*c.* 1536
Philadelphia, John G.
Johnson Collection
104a Preparatory drawing
Windsor Castle, Royal
Collection

105 Elizabeth Widmerpole
Oil and tempera on wood/
32.5 × 25/s./*c.* 1536
Winterthur, Oskar Reinhart
Collection

106 Henry VIII
Oil and tempera on wood/
28 × 20/*c.* 1536–7
Castagnola (Lugano),
Thyssen-Bornemisza
Collection

107 Jane Seymour
Oil and tempera on wood/
65.4 × 40.7/*c.* 1536–7
Vienna, Kunsthistorisches
Museum
107a Preparatory drawing,
also related to No. 108
Windsor Castle, Royal
Collection

108 Jane Seymour
Oil and tempera on wood/
26.3 × 18.7/*c.* 1536–7
The Hague, Mauritshuis

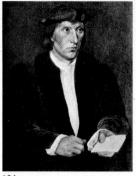

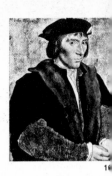

104

10

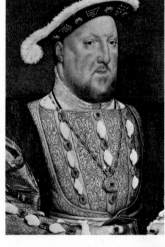
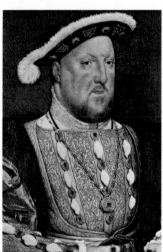

106

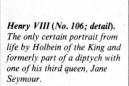

Henry VIII (No. 106; detail).
The only certain portrait from
life by Holbein of the King and
formerly part of a diptych with
one of his third queen, Jane
Seymour.

105

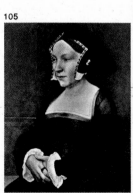
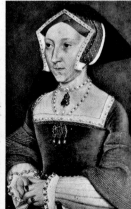

74

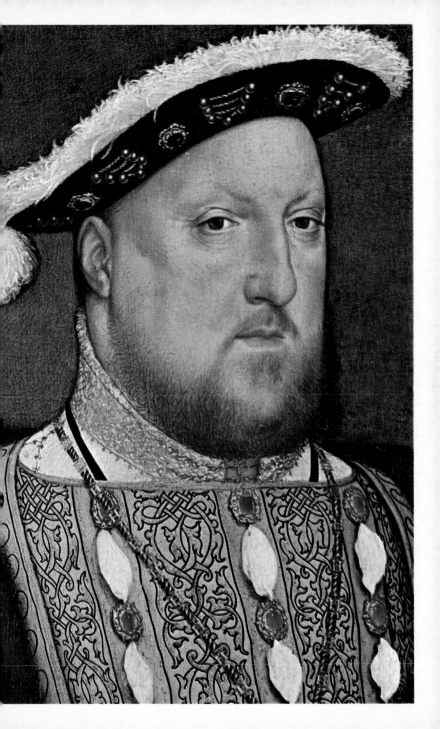

109 Young Man
Oil and tempera on wood/
39 × 31.5/d. 1537
Paris, Schaefer Collection

**WALL-PAINTING FOR
THE PRIVY CHAMBER
OF WHITEHALL PALACE,
LONDON**
1537
Lost work known from the
works listed below:
**110a Cartoon drawing for the
figures of Henry VII and
Henry VIII**
London, National Portrait
Gallery
**110b R. van Leemput. Copy of
the wall-painting** (1667)
Hampton Court, Royal
Collection
110c Henry VIII
(copied from the Whitehall
wall-painting)
London, National Trust,
Petworth House
Not Illustrated
110d Henry VIII
Early portrait version based
on the wall-painting
Rome, Galleria Nazionale
110e Henry VIII
Early portrait version based
on the wall-painting
Windsor Castle, Royal
Collection

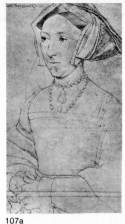

107a

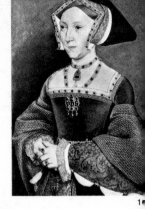

1●

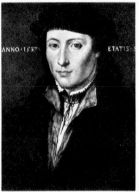

109

11●

*Jane Seymour (No. 107).
Henry VIII's third queen and
mother of Edward VI. The
formula is typical of all
Holbein's portraits of ladies of
the court during his final
period, an abandonment of any
background setting and a
rendering of both features and
dress in microscopic detail.*

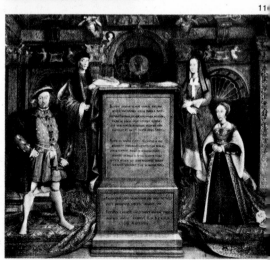

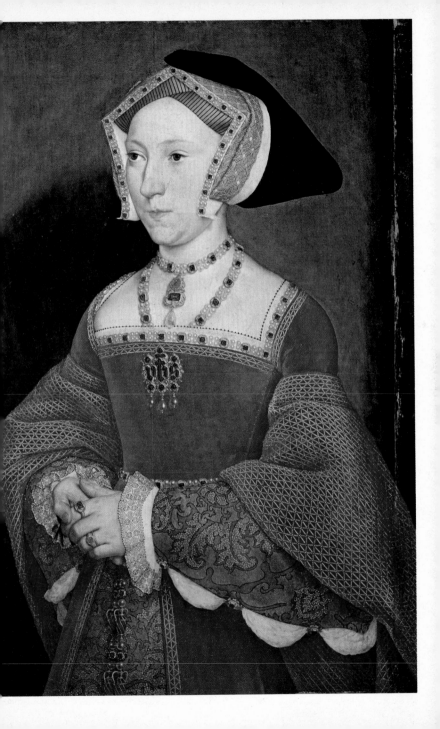

111 Sir Thomas Wyatt the Elder
c. 1537–40
Lost work known from a woodcut by Holbein (in J. Leland, *Naenia*, 1548) and two early versions (London, National Gallery and Oxford, Bodleian Library)

112 Christina, Duchess of Milan
Oil and tempera on wood/ 179 × 82.5/1538
London, National Gallery

113 George Brooke, 9th Lord Cobham
c. 1538–40
Lost work known from a drawing (Windsor Castle, Royal Collection) and an early version (London, Art Market)

114 Edward VI
Oil and tempera on wood/ 57 × 44/1539
Washington, National Gallery of Art
A preparatory drawing is known, No. 114a (Windsor Castle, Royal Collection) as well as an early version (Syon House, Duke of Northumberland)

Edward VI (No. 114, detail).
Probably presented to Henry VIII as a New Year's gift, the portrait is accompanied by laudatory Latin verses – which exhort the prince to attempt to surpass his father – composed by one of Thomas Cromwell's chief apologists for the Reformation, Richard Morison.

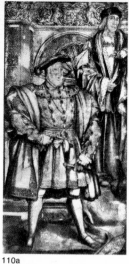
110a

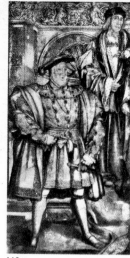
1

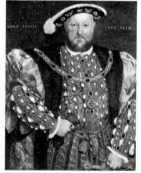
110c

11

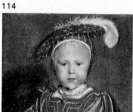
114

114

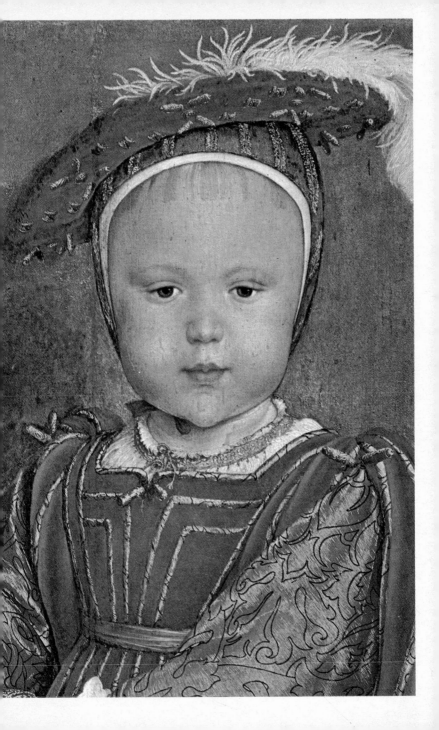

115 Anne of Cleves
Oil and tempera on paper
mounted on canvas/65 × 48/
1539
Paris, Louvre

116 Sir Bryan Tuke
Oil and tempera on wood/
49 × 39/c. 1539–41
Washington, National
Gallery of Art
Two early versions are known
(Cleveland, Museum of Art,
and Munich, Alte
Pinakothek)

**117 Thomas Howard, 3rd
Duke of Norfolk**
Oil and tempera on wood/
80.6 × 60.9/c. 1539–40
Windsor Castle, Royal
Collection
An early version is known
(UK, Trustees of Arundel
Castle)

**118 John Russell, 3rd Earl of
Bedford**
c. 1539–40
Lost work known from a
drawing, No. 118a (Windsor
Castle, Royal Collection) and
an early version (Woburn
Abbey, Trustees of the
Bedford Settled Estates)

119 Unknown Man
Oil and tempera on wood/
32.5 × 26/c. 1540
Basel, Öffentliche
Kunstsammlung

**120 Margaret Wyatt, Lady
Lee**
Oil and tempera on wood/
42.5 × 32.7/c. 1540
New York, Metropolitan
Museum of Art

*Anne of Cleves (No. 115;
detail).*
*Henry VIII's fourth queen and
daughter of the Duke of
Cleves, she was painted by
Holbein in July 1539 as a
prospective bride for the King.
The choice of a frontal image,
which he used for the other
prospective bride, Christina,
Duchess of Milan (No. 112),
reflects the increasingly iconic
quality of his late portraits.*

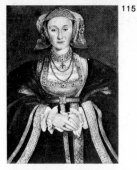
115

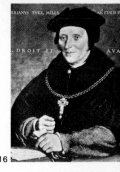

116

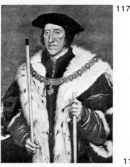
117

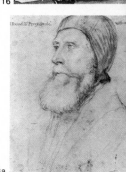

118a

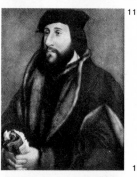
119

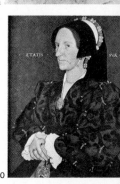

120

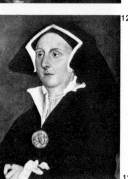
121

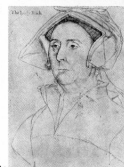
121a

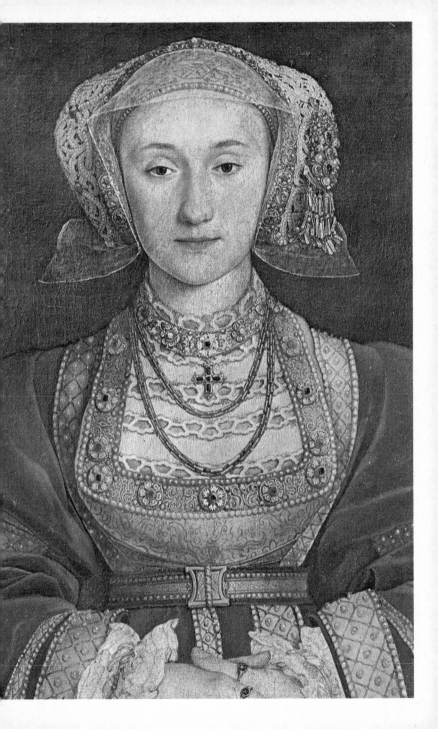

121 Elizabeth, Lady Rich
Oil and tempera on wood/
44.5 × 35/c. 1540
Switzerland, Private
Collection
An early version is known
(New York, Metropolitan
Museum of Art) as well as
the preparatory drawings for
the painting and for a
possible pendant to it with Sir
Richard Rich (Windsor
Castle, Royal Collection,
Nos. 121a and 121b)

122 Unknown Lady
Oil and tempera on wood/
29.8 × 24.8/c. 1540
New York, Metropolitan
Museum of Art

**123 Unknown Lady formerly
called Catherine Howard**
Oil and tempera on wood/
74 × 51/c. 1540
Toledo (Ohio), Museum of
Art
An early version is known
(London, National Portrait
Gallery)

124 John Poyntz of Alderley
c. 1540
Lost work known from a
drawing, No. 124a (Windsor
Castle, Royal Collection) and
an early version (Sandon
Hall, Earl of Harrowby)

125 Unknown Man
Oil and tempera on wood/
56 × 48/c. 1540
London, Courtauld Institute
of Art
Attributed work

126 Woman in a White Coif
Oil and tempera on wood/
diam. 11/d. 1541
Los Angeles, County
Museum of Art
Attributed work

**127 A Member of the Family
de Vos van Steenwijk**
Oil and tempera on wood/
47 × 36/d. 1541
Berlin-Dahlem, Staatliche
Museen, Gemäldegalerie

128 Unknown Man
Oil and tempera on wood/
46.5 × 34.8/d. 1541
Vienna, Kunsthistorisches
Museum

82

121b

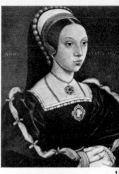
12

123

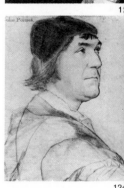
124

125

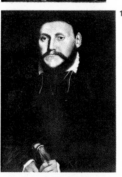

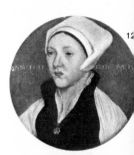
12

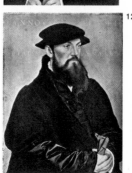
127

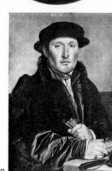
128

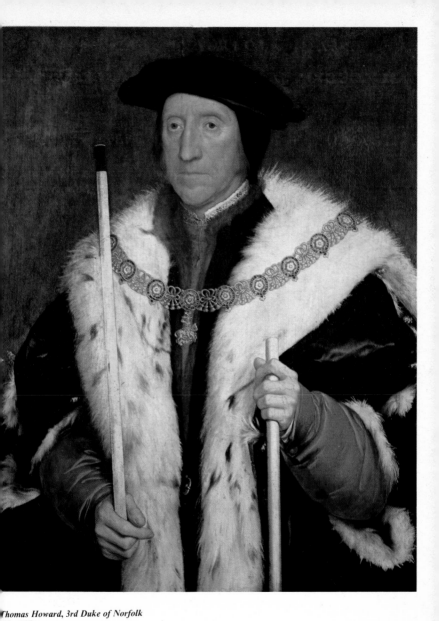

Thomas Howard, 3rd Duke of Norfolk (No. 117).
One of the most important officers at the court of Henry VIII, he carries the gold baton of Earl Marshal and the white staff of Lord Treasurer. Catherine Howard was his niece. Norfolk fell from power in 1546, remaining in prison until released by Mary I.

129 Unknown Lady
Oil and tempera on wood/
19.2 × 15.3/*c.* 1541–3
Vienna, Kunsthistorisches
Museum

**130 Henry VIII and the
Barber Surgeons**
Oil on wood/180.3 × 312.4/
1541–3
London, Barbers Hall

**131 Henry VIII and the
Barber Surgeons**
Oil on paper mounted on
canvas/160 × 280/1541–3
London, Royal College of
Surgeons
Overpainted cartoon for
No. 130

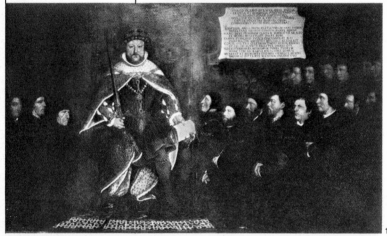
129

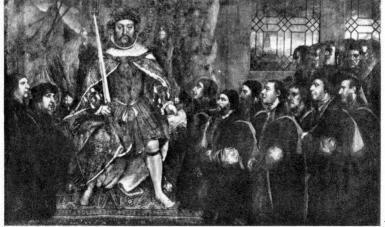
130

131

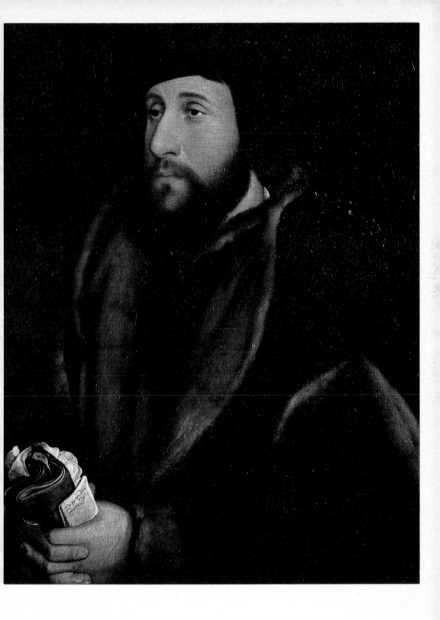

Unknown Man (No. 119).
*A typical portrait of a man of
the lesser gentry or bourgeois
class and treated therefore
without the bejewelled
formalism of the court sitters.*

85

132 Sir Thomas Wyatt the Younger
Oil on wood/diam. 32/
c. 1540–43
London, Christopher Gibbs Ltd

133 Dr John Chambers
Oil and tempera on wood/
58 × 39.7/1541–3
Vienna, Kunsthistorisches Museum

134 Henry Howard, Earl of Surrey
Oil and tempera on wood/
55.5 × 44/1541–3
São Paulo, Museu de Arte

135 Man with a Falcon
Oil and tempera on wood/
25 × 19/d. 1542
The Hague, Mauritshuis

136 Henry VIII
Oil and tempera on wood/
92 × 66.6/d. 1542
Castle Howard, Howard Collection
Attributed work

Margaret Wyatt, Lady Lee (No. 120).
Sister of the poet, Sir Thomas Wyatt, and mother of Queen Elizabeth's Master of the Armoury, Sir Henry Lee. The scale is about half life size and reflects Holbein's fascination with scale during the period in which he was being taught miniature painting by Lucas Hornebolte.

133

132

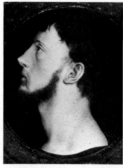

13

135

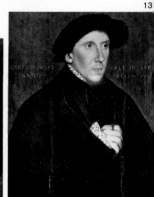

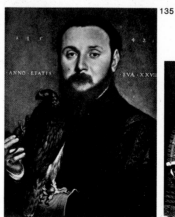

136

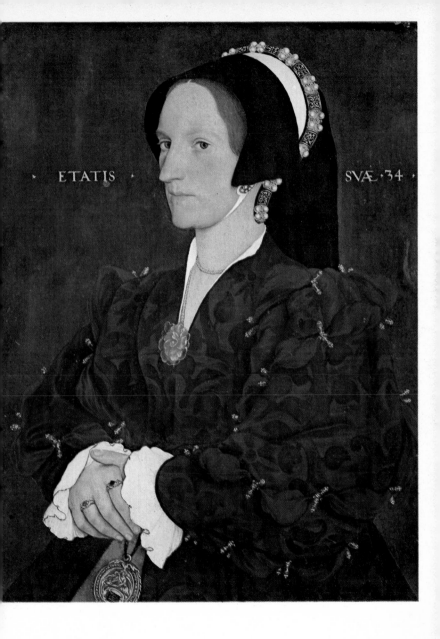

ETATIS · SVÆ · 34 ·

137 Self-Portrait
1542
Lost work known from an
early version, No. 137a
(Indianapolis, Clowes Fund
Collection)

**138 William Fitzwilliam, Earl
of Southampton**
1542(?)
Lost work known from a
drawing (Windsor Castle,
Royal Collection) and an
early version (Cambridge,
Fitzwilliam Museum)
Not illustrated

139 Sir George Carew
Oil and tempera on wood/
diam. 33.6/*c.* 1542–3
Weston Park (Shifnal), Earl
of Bradford
139a Preparatory drawing
Windsor Castle, Royal
Collection

140 Sir William Butts
Oil and tempera on wood/
47 × 36.8/*c.* 1543
Boston, Isabella Stewart
Gardner Museum
Pendant to No. 141

141 Lady Margaret Butts
Oil and tempera on wood/
46 × 37/1543
Boston, Isabella Stewart
Gardner Museum
Pendant to No. 140
141a Preparatory drawing
Windsor Castle, Royal
Collection

Unknown Lady (No. 123).
Formerly wrongly identified as
Henry VIII's fifth queen,
Catherine Howard, the sitter
is likely to be a member of the
Cromwell family. The
recession from reality in the
placing of the figure is
reinforced by floating an
inscription across the
background.

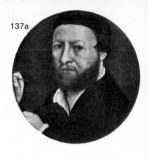

137a

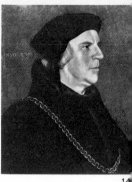

14

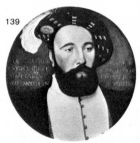

139

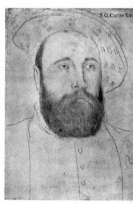

S. G. Carow Knig

139

141

ANNO ÆTATIS SVÆ LXII

141a

The Lady Buts

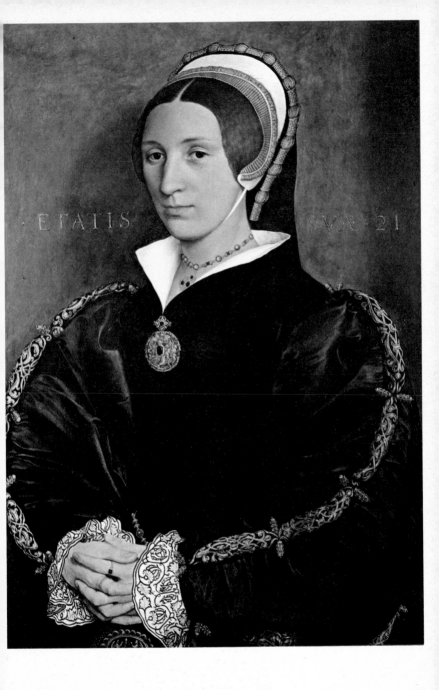

142 Anton the Good, Duke of Lorraine
Oil and tempera on wood/
51 × 37/1543
Berlin-Dahlem, Staatliche
Museen, Gemaldegalerie

143 Sir William Butts
Oil and tempera on wood/
74 × 59.5/d. 1543
Boston, Museum of Fine Arts
Attributed work

144 Edward VI as Prince of Wales
Oil and tempera on panel/
diam. 32.4/d. 1543
New York, Metropolitan
Museum of Art
Attributed work

145 Called the Princess Mary
Oil and tempera on wood/
diam. 37/c. 1543
London, Private Collection
Attributed work

Dr John Chambers (No. 133).
Physician to Henry VIII and
Master of the Barber
Surgeons Company. As in the
case of Sir William Butts
(No. 140) the same sitting
was used for the likeness in the
great Barber Surgeons group
(No. 130).

Sir William Butts (No. 140;
detail). (p. 92)
Physician to Henry VIII, the
portrait is typical of the flat
formalized treatment of sitters
during the artist's last years.

Lady Margaret Butts
(No. 141, detail). (p. 93)
Like the companion portrait of
her husband (No. 140), the
picture is typical of the artist's
flat final style. Lady Butts was
of Protestant persuasion and
was closely associated with the
circle of Henry VIII's last
queen, Catherine Parr.

90

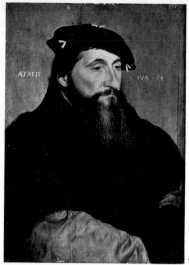

142

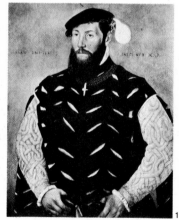

143

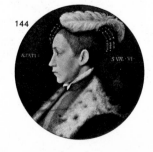

144

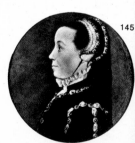

145

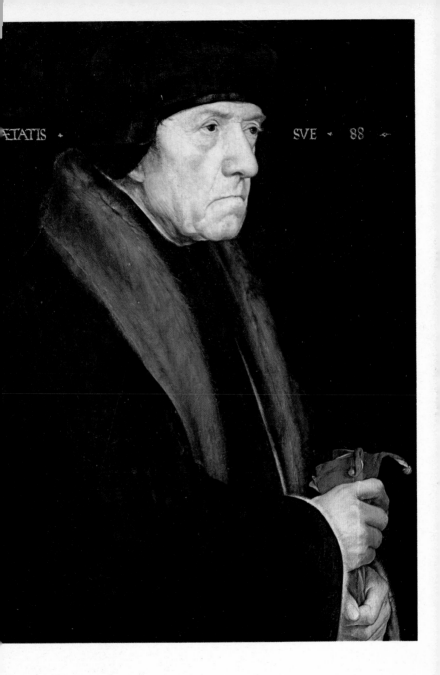

ÆTATIS · SVE · 88 ·

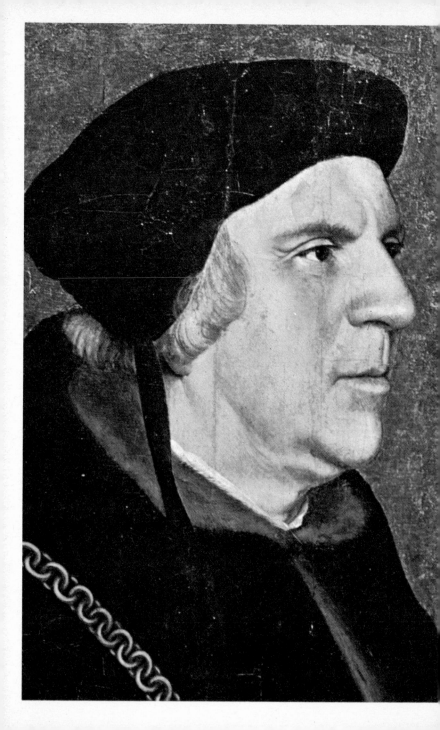

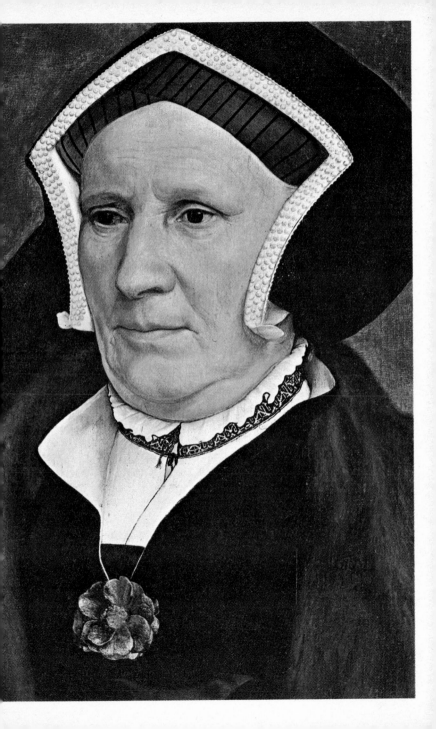

MINIATURES

146 George Neville, Lord Abergavenny
Watercolour on card/
diam. 5.5/*c.* 1535
UK, Duke of Buccleuch
Not illustrated

147 William Roper of Well Hall
Watercolour on card/diam. 3/
1536
New York, Metropolitan
Museum of Art
Not illustrated

148 Margaret More
Watercolour on card/diam. 3/
1536
New York, Metropolitan
Museum of Art
Not illustrated

149 Anne of Cleves
Watercolour on card/
diam. 4.5/*c.* 1539–40
London, Victoria and Albert
Museum

150 Mrs Pemberton
Watercolour on card/
diam. 5.4/*c.* 1540
London, Victoria and Albert
Museum

151 Called Catherine Howard
Watercolour on card/diam. 2/
c. 1540
UK, Duke of Buccleuch
Collection

152 Called Catherine Howard
Watercolour on card/
diam. 5.8/*c.* 1540
Windsor Castle, Royal
Collection

153 Lady Elizabeth Audley
Watercolour on card/
diam. 5.5/*c.* 1540–3
Windsor Castle, Royal
Collection

154 Henry Brandon, son of Charles Brandon, Duke of Suffolk
Watercolour on card/
diam. 4.7/1541
Windsor Castle, Royal
Collection

155 Charles Brandon, son of Charles Brandon, Duke of Suffolk
Watercolour on card/
diam. 4.7/1541
Windsor Castle, Royal
Collection

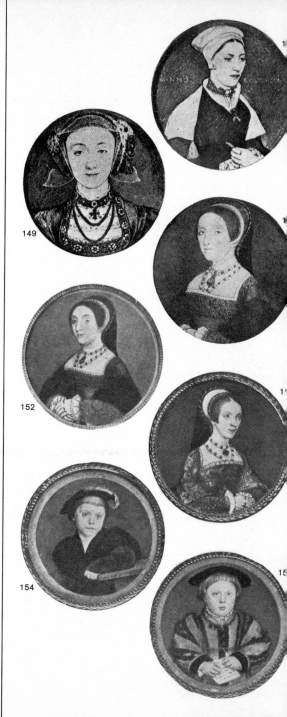

149

152

154

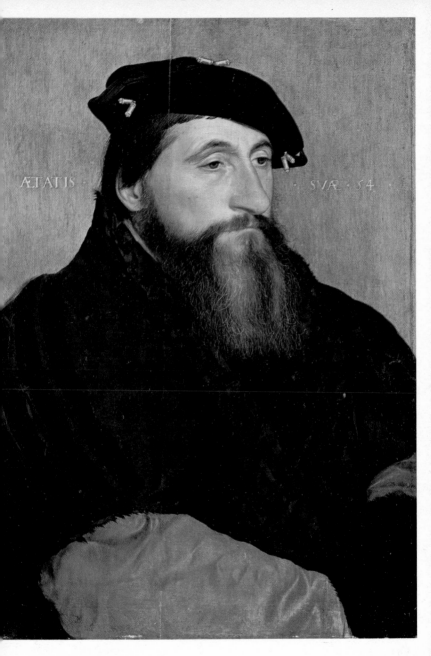

Anton the Good, Duke of Lorraine (No. 142).
*The age of the sitter dates the painting at 1543. The
identification as the soldier Duke Anton was made in
1927 and has not since been questioned.*

Select Bibliography

A. B. Chamberlain, *Hans Holbein the Younger*, London 1913

P. Ganz, *The Paintings of Hans Holbein the Younger*, London 1950

Holbein and the Court of Henry VIII, Queen's Gallery, Buckingham Palace, 1978–9 (Exhibition Catalogue)

K. T. Parker, *The Drawings of Hans Holbein in the Collection of H.M. The King at Windsor Castle*, London 1945

F. Saxl, 'Holbein and the Reformation', *Lectures*, London 1957, I, pp. 277–85

H. A. Schmidt, *Hans Holbein der Jüngere*, Basel 1948

Roy Strong, *Holbein and Henry VIII*, London 1967

Photocredit
All the photographs are from the Rizzoli Photoarchive

First published in the United States of America 1980 by Rizzoli International Publications, Inc.
712 Fifth Avenue, New York, New York 10019
Copyright © Rizzoli Editore 1979
ISBN 0-8478-0311-2
LC 80-50232
Printed in Italy